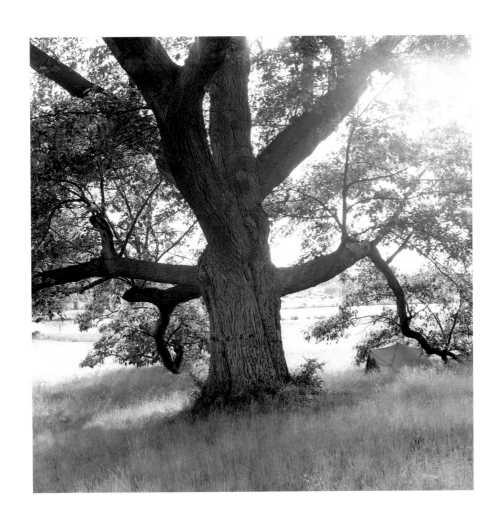

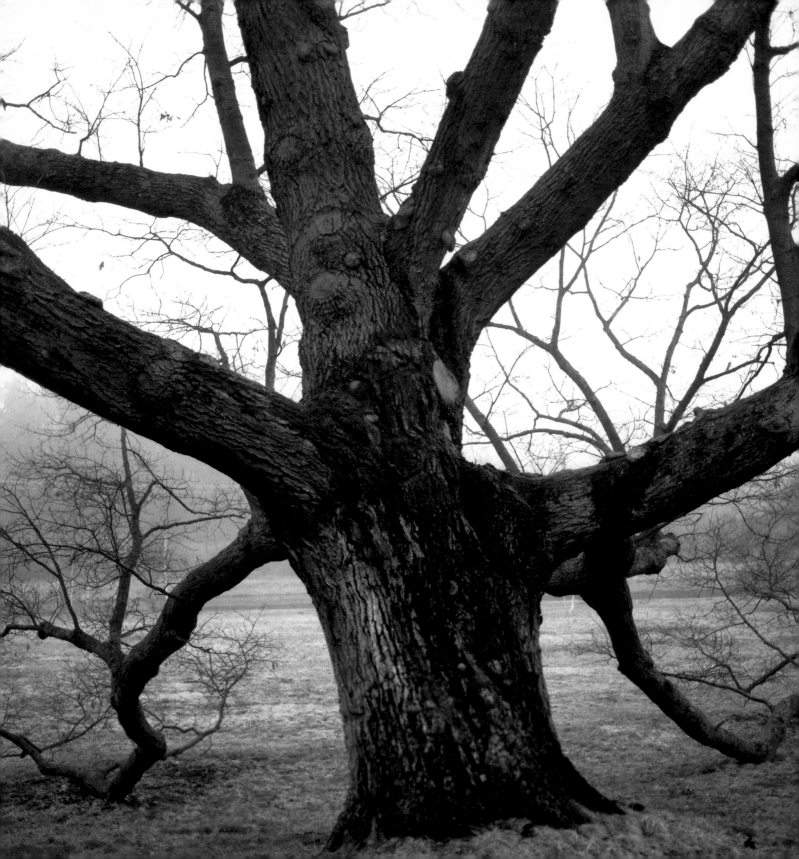

The Oak Behind the House

B. A. King

A BLACK ICE BOOK

Published by *The Quantuck Lane Press*

NEW YORK

Library of Congress Cataloging-in-Publication Data
King, B. A.
The oak behind the house / B. A. King.
p. cm.
"A Black Ice Book."
ISBN 978-1-59372-029-2
1. Photography of trees. 2. Oak—Pictorial works. 3. King, B. A. I. Title.
TR726.T7K57 2007
779'.34—dc22
2007009381

The Quantuck Lane Press
New York
www.quantucklanepress.com

Distributed by:
W.W. Norton & Company, 500 Fifth Avenue, New York, NY 10110
www.wwnorton.com

W.W. Norton & Company Ltd., Castle House, 75/76 Wells Street, London, WIT 3QT

1 2 3 4 5 6 7 8 9 0

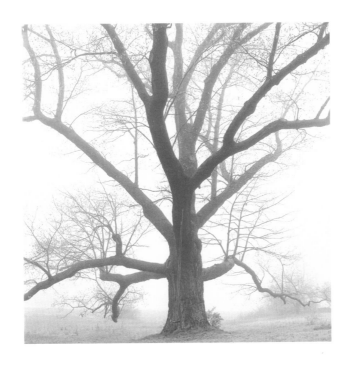

This book is dedicated to the grown-ups of my childhood

who took me among trees,

and to Judy, my wife,

and our children, Jen, Will, Wendy, and Bruce,

who also love the oak and helped me to see it and everything else

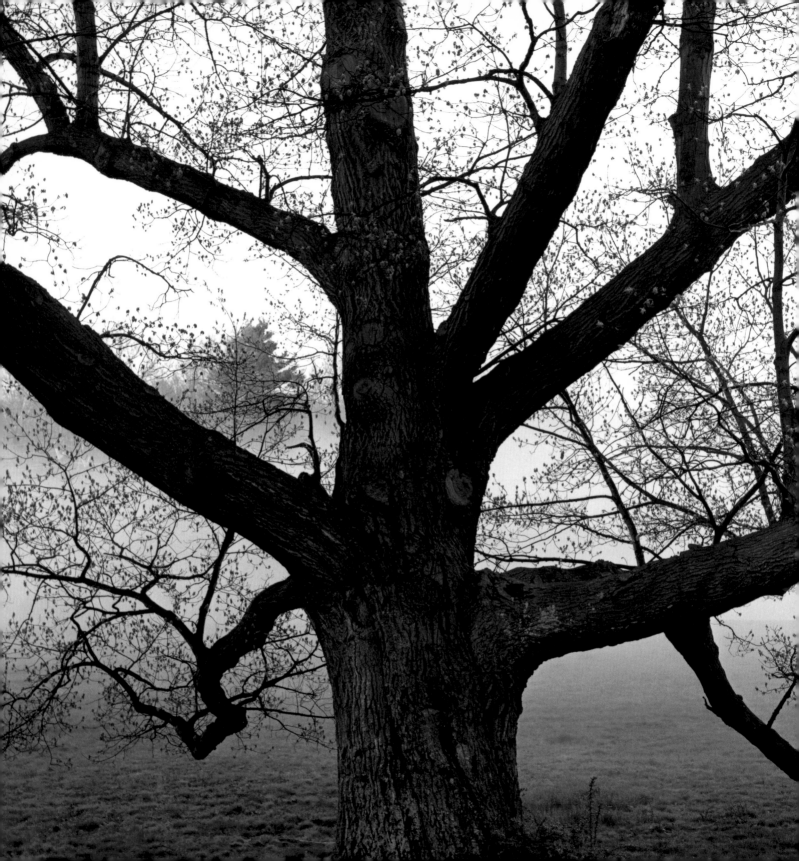

Introduction

B. A. King is renowned as a photographer of places. His images of those that have touched him most deeply — such as the forests and lakes of Ontario and New Brunswick, and the deserts and mountains of Arizona and Montana — have a pensive solitude that reflects the artist's personality. Over a lifetime, King has refined his consideration of landscape. As a boy, he enjoyed being alone as much as with friends. It was nature that transfixed him. Behind his family's home in central Toronto, the yard fell away into a ravine, under a canopy of trees and thick with undergrowth. At the bottom of the dale, a trickling brook teemed with insects and amphibians. To the boy it seemed like a vestibule to the Canadian wilderness. Paradoxically, he longed to share these solitary delights, and took some of his first snapshots in the ravine.

Decades later, while pursuing a successful career in business and continuing to work as a naturalist photographer, King explored portraiture in his photographs for James Houston's book *Ojibwa Summer.* His sensitive images of Native Canadians, taken on the Reserves of Central Ontario, capture the grace and humanity of a private people. Most compelling among them are portraits in action. Glimpses of Ojibwa men fishing, working at a charcoal kiln, or meeting in tribal council reflect their close connections to nature and community. These

images also embody the photographer's fascination with the individual's place in society and in the world. The project taught him how to use character to convey his ideas, and how to develop a theme through a series of images. In his photoessay on the Harvard Business School, King strove to capture the institution's human dimensions. Over the course of an academic year, he documented activities at the school in classrooms, libraries, and corridors. Students, professors, and staff work together, confer and debate, and let off steam in a snowball fight. Human interaction is the series' leitmotif, but for the viewer to whom these people are strangers, what emerges is a memorable sense of place. One can imagine studying in that hallowed institution, toiling, socializing, and daydreaming there, and discovering one's self.

King's creative voice emerged, clear and distinctive, in his photographs for *The Faces of the Great Lakes*, a Sierra Club book. For this challenging project, the photographer coupled anonymous portrait studies with landscapes, vast and intimate. He spent many hours in a small plane collecting aerial views, as he traveled in a circuit around the lakes' shores. The views of the wilderness and its natural beauty are stunning. Images of icy winter mornings and temperate summer afternoons reveal not only climate, but the scale and character of rugged geology, vast waters, and endless woodlands. In this book, as never before, King revealed his proclivity for design. The photographer has an uncanny intuition for when to confront a subject face on, and when to seek an unusual viewpoint. He found surprising perspectives of man-made objects in nature. Muscular industrial plants lining the lake shores challenge the harsh climate, symbols

of human ingenuity and might. Other constructions accord with nature, like the Mackinac Bridge from above, casting its delicate shadow on stippled water, or the viaduct spanning the Genessee River Gorge, its tensile threads in linear counterpoint to immoveable geology and flowing water. King conveyed how it feels for the region's people to live with their land. Some of the series' most compelling images depict figures in the landscape, struggling against the elements, and making use of them. One identifies easily with these people.

In the following decades, King's photographs became more comfortable, and more accessible. Without the pressure of working on assignment, and left to wander with his camera, he discovered affable images and events to move him. He continued to explore nature and places like the farm or beach, where people confront their environment. Some of his most affecting images are deserted landscapes that reveal nature's changeability: a bare tree silhouetted against a cloudless sky, snow drifting over a neglected hay rake that casts a calligraphic shadow, or the organic patterns of weathered shingles on the side of a barn. King's carefully chosen locations provide settings for sympathetic characters and subtle action. Ambiance helps to define the subjects. With gentle humor, the photographer depicts characters that are blithe and irascible. "Dramas take place most often around the edges of things," King once wrote. His brilliance is an ability to capture decisive moments of those dramas, while thoughtfully leaving room for the viewer's own imagination. It takes great intuition and skill to position oneself for these fleeting events, and to set subjects at ease so they can happen naturally. Children and animals seem comfortable before his lens.

The images reveal that the photographer spent a very long time in quiet consideration, waiting to snap the shutter.

King is perhaps most comfortable in New England, his adopted home. Ironically, however, this hard, austere place prompts him to become less formal, even mischievous. Many of his New England photographs capture history and feelings of nostalgia, a sense of the way things used to be. They describe a traditional place, where life seems slower, perhaps less threatening, and certainly more contemplative. This New England seems to be a place where — if only in the imagination — one can be true to oneself, unguarded and relaxed. King's books of New England photographs are all the more pleasing for his own carefully chosen words. Rather than describe, his spare comments inflect, like the clipped byplay between friends passing momentarily on a village street. Characteristically, these remarks pique our own thoughts. Other writers have provided literary counterpoint for King's photographs, like Hal Borlund, whose prose characterizes New England while celebrating the region. The photographer's acquaintance with Edward Connery Lathem — a friend and editor of Robert Frost — led to books like *Versed in Country Things* and *Snow Season*. King's black-and-white photographs perfectly complement Frost's verse and the New England poetry of authors like Henry Wadsworth Longfellow, John Greenleaf Whittier, and James Russell Lowell.

In his book *This Proud Place*, King recalls his conversation with a Maine logger and clam digger, who lived a seasonal life close to poverty. "You are really deprived of things," the old man said, "but it's kind of purifying." The photog-

rapher provides a similar vision in his purposeful economy of line and form, in counterpoint with open space. He often prints his photographs in high contrast, to deepen shadows, intensify highlights, and give a granular texture to modeled passages. When working in color, King sometimes employs a soft palette, close in value, as if the hues were sunbleached, or muted by a misty day. The color photographs in the series *Time and Quiet* are more naturalistic but no less evocative. Perhaps more than any other, this book reflects the fundamental activities as a naturalist photographer that King has pursued throughout his career. Figures are nearly absent from the series of landscapes and studies of flora and fauna. The photographs were taken with hand-held cameras and an array of lenses, in natural light, often from a canoe or from horseback. The images reveal the captivating beauty of what are, after all, commonplace events, on ordinary days in the natural world. Their scale and environments range widely — from water striders on the surface of a pond after a summer rainshower to humpback whales surfacing from frigid ocean depths — but their experience provides a common thrill. King's photographs of nature disclose the secret of his method, and his success in picturing people. Quite simply, he spends hours in silent, passive observation. Passionate in the solitary experience of nature, he watches and waits patiently to capture a decisive moment that can relate his experience.

The Oak Behind the House is a quintessential book for King. It represents a cherished natural place, and the human station in the greater world. Though its subject may be an insentient being, a personality emerges, so intensely observed that the suite can be characterized as portraiture. Many of the photographs

capture life's minor dramas, occurring at the periphery or buried in the middle of a larger view. Spartan compositions include provocative open space or vaporous atmosphere. These images reveal a subject and events in a deeply personal manner unprecedented in the photographer's oeuvre. The series depicts a magnificent Northern Red Oak tree behind the house in Southborough, Massachusetts, where King and his wife, Judy, raised their four children. When the family moved to the old house, the enormous tree provided instant delight. For each child, the oak offered a captivating personal connection to nature, like their father's ravine. It became King's constant model. Over many years, he photographed the tree casually, at all times of day, in every season and weather.

With its scars, burls, and wrinkled trunk, the old tree seemed to have the visage of a wise patriarch. Its low branches spread wide like the welcoming arms of a jolly great-uncle. Somehow the oak's kind and venerable personality made it seem improper for a photographic essay. Occasionally King published or exhibited selected shots of the tree — like those of his children — but for the most part he protected its privacy. The oak also touched the lives of those outside the King family. Their friend, the author Robert Forbes Perkins, was married in a service under its branches, which provided sheltering fellowship despite a rainy day. A New England arborist came to visit the tree after seeing one of King's pictures in the *Boston Globe.* He was so moved that he had a portraitlike image of the oak tattooed across his back, above the inscription *Quercus borealis King*. Will King, who grew up to become proprietor of a Montana guest ranch, has the tree's image carved in the horn of his saddle and tooled in the leather cover of a canteen.

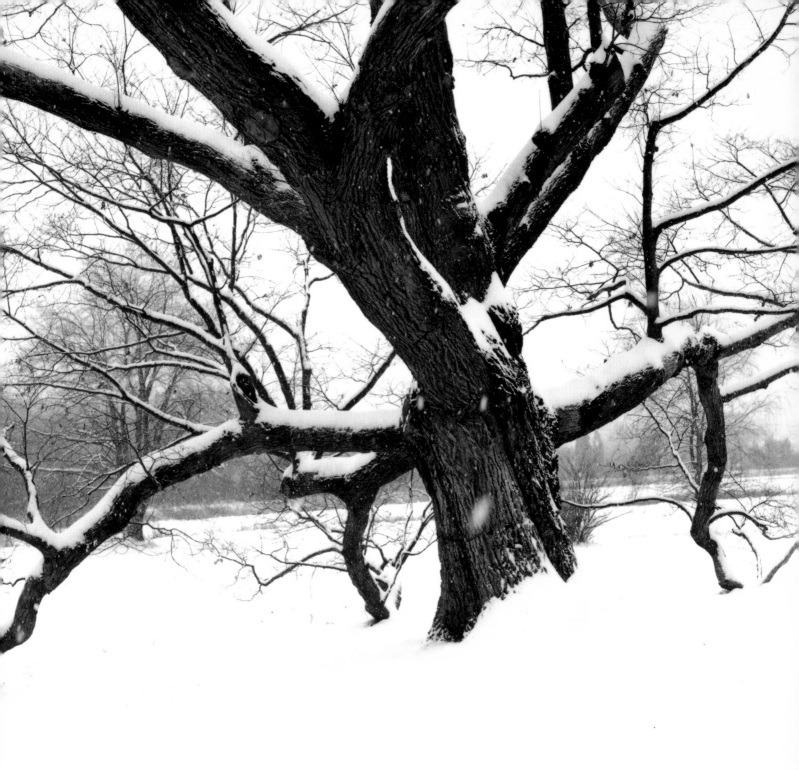

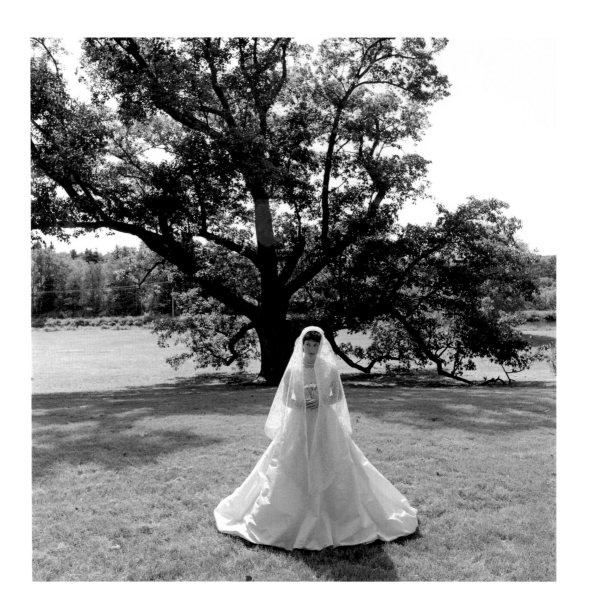

It was only from the perspective of years that King realized what a moving story his images of the tree could tell. He began to scour old files and albums to compile a selection of photographs, often printing from negatives that had lain neglected for years. King chose substantial moments that reveal the tree's rich life, its relationships to its environment, to his family, and to himself. He organized this group into a slide show that he presented to arborists, gardeners, and other local groups. Their enthusiasm prompted him to continue, and audience comments suggested how to expand the presentation, and even how to refine his photographic process. King discovered anew how powerfully his work could evoke association, and that many people cherish memories of one special tree in their own lives. In response to his lecture, one friend aptly observed that he had become the oak's curator. These photographs reveal that all the Kings had joined the tree's family.

These pictures allow us to absorb the life lessons that the ancient tree could teach. The oak told tales about history and the importance of the present, about transience, and about inheritance. The photographs reveal truths about the power of common experience, about the importance of family in both its nearest and broadest sense. B. A. King's most profound photographic series invites us all to share in comfortable family traditions, in achievement and repose, loss and sorrow, redemption and ultimate understanding.

— DAVID ACTON *Worcester Art Museum*

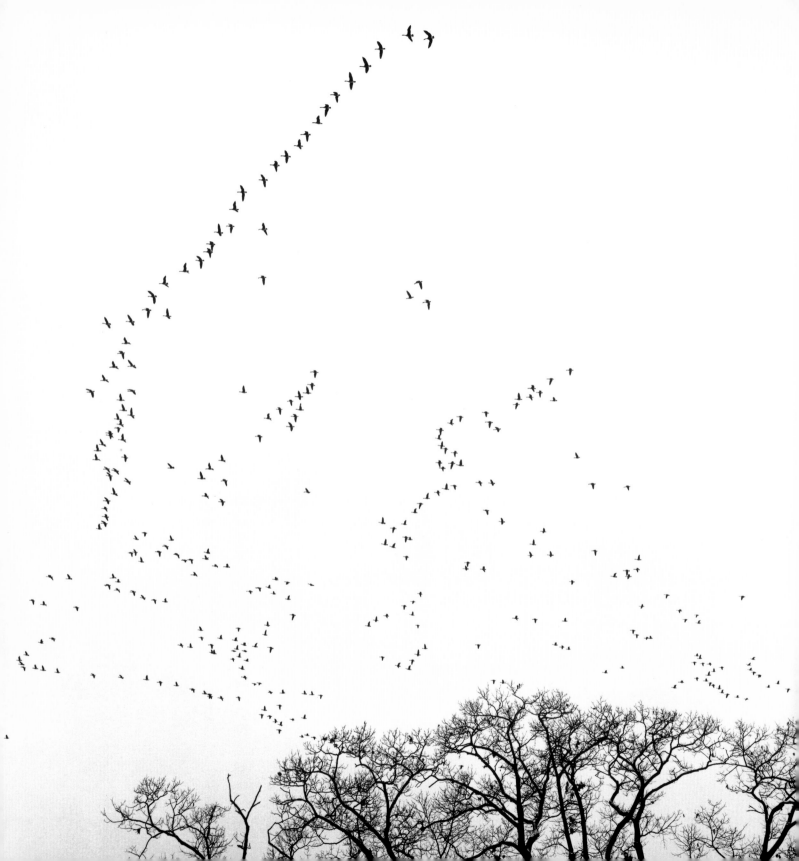

Getting Started

Since I was a child I've had a need to show people things — things I thought were important, special, funny, or wonderful. At first it was birds' nests in the woods or big fish under docks. I loved bedtime stories and being read to. We listened a lot to news on the radio because my father was overseas for the whole of World War II. Important events were described in stirring language. My mother and grandmother were always reading books, and I could see that people who worked with words meant a lot. I knew I wanted to be a writer. It didn't occur to me that you needed to know how to read to be able to write.

I had trouble with schoolwork and my teachers didn't pay much attention to me, which suited me fine. Mother told me years later that she had wondered if I would ever learn to read and write. I didn't find out until I was in my forties that I am dyslexic. I had some friends at school and enjoyed sports, but I was always anxious to get home.

One of the glories of Toronto is the system of ravines that crisscrosses the city. Behind our house the ravine was wide and deep, and after school that was often where I'd be. From our front yard you could hear streetcars and traffic but at the back of the house, if you slipped over the lip of the ravine, you entered a different world. In the ravine I saw my first owl and fox. There was a creek at the

bottom and a frog pond with turtles and salamanders. I built forts and campsites and cooked out. I could be anything I wanted to be in the ravine. Every night I prayed for my Dad to come home safely and that I would grow to be six-feet tall, which you had to be to join the Royal Canadian Mounted Police.

We spent summers at Kennebunk Beach, Maine, with my mother's parents. I was free to explore beaches and tide pools and the woods behind salt marshes. I got to know farmers and fishermen. To raise pocket money I did some caddying, and met local boys who taught me some vivid language.

Just before my eleventh birthday, Dad came home from the war and was disgusted with my academic condition. Because I wanted to please him more than anything, I started to take schoolwork very seriously. Thinking about my growing up, I feel lucky to have had a free period at the beginning, when I could follow my inclinations and find out what really interested me. And I think my father set me to book-learning in the nick of time.

I am fundamentally a naturalist, although untrained, and my favorite species is our own. I'm fascinated by human doings, and dazzled by human potential.

The spring following Dad's return, I was sent to camp. As I stepped onto the train that carried me and hundreds of other children north, Mother handed me her Kodak Brownie Special and suggested that I take some pictures "so you can show me what it was like." Although I didn't realize it for many years, in that moment I was handed my future. Mother wasn't big on compliments, but I was aware she showed my snapshots to her friends. I still have those pictures.

Taking pictures was fun, and for a long time I'd take up photography and put it down, just as I did with other activities like fishing, golf, and archery. I took pictures in jags, mainly when I was on trips. I photographed boats, cars, dogs, people in the streets and in the fields, sporting events, and especially nature. But I didn't know any photographers, and it never occurred to me to be one. I still wanted to write. In high school I contributed a piece to each issue of the school magazine and was literary editor in my last year. But my writing met with almost no success in college. Only one story in four years was accepted by the literary magazine, and that had to be so extensively edited that the editor and I were listed as co-authors. After college I worked for my grandfather, who owned a small company that distributed pipe, valves, and fittings in Worcester, Massachusetts, and I wrote in my spare time and on weekends. I wrote stories and articles, and started a novel. I wasn't able to get anything published, and I could see that that was for good reason. Finally, nearing thirty, I admitted to myself that I had tried hard enough, so that if there was any hope of becoming a writer, some slight promise of it would have appeared by then. I realized I needed another form of expression. The night of July 30, 1961, was hot, and I was thinking about this dilemma while walking with Judy, my wife, who was pregnant with our second child. I remembered Mother showing my snapshots to her friends. The next morning I bought a Kodak Retina IIIC, and the day after that Judy and I went to Cuttyhunk for a week. That is when I really began to become a photographer.

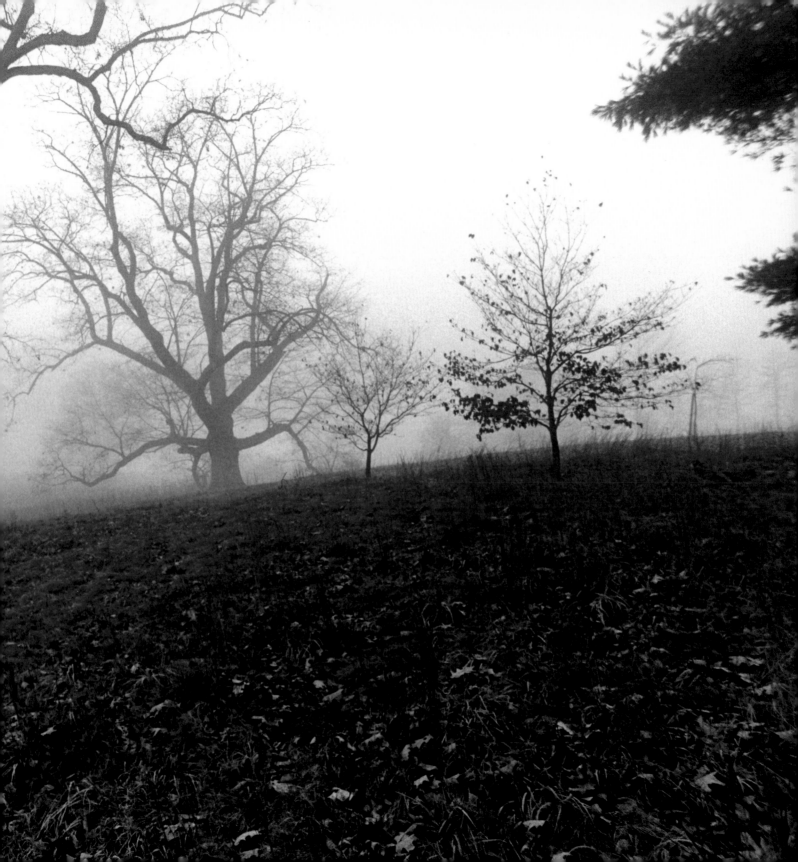

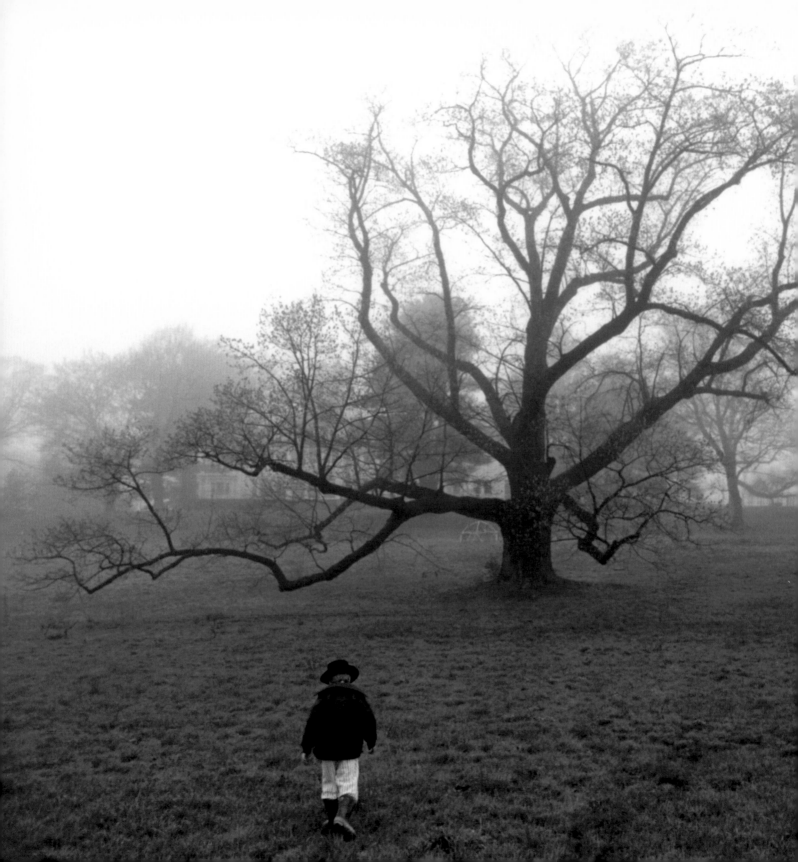

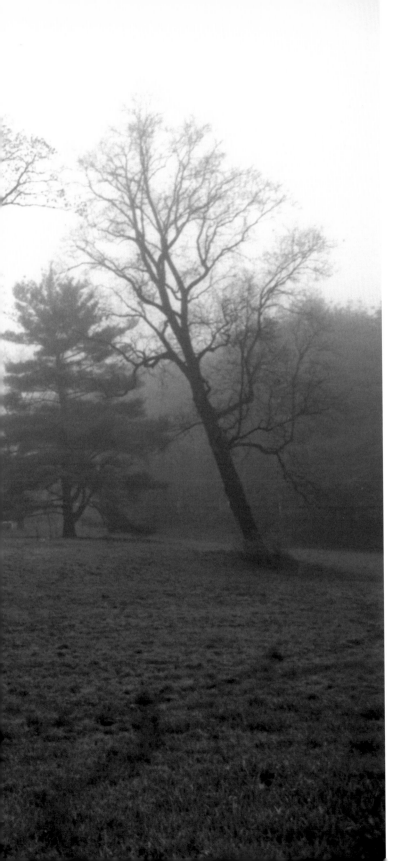

When the youngest of our four children was six months old, we were invited by dear friends to purchase a house next to their farm in Southborough. We wanted to move to the country so our children would grow up familiar and on good terms with nature. Our house is a rattley old place, built as a summer house in 1904, and given as a wedding present by the bride's father. It is insulated with horsehair and seaweed, and is a fine place to play hide-and-seek. Surrounding the house were woods and farm fields. From our kitchen table we could see cows, and across the street stood a cattle-crossing sign. Along the bottom of the property runs Stony Brook, an ample farm stream, still natural looking in spite of being channeled slightly when it became part of the reservoir system.

And there was a big tree, which could be seen from almost every room in the house. Our children grew up in and around that tree.

We arrived in Southborough in 1969. Immediately the town's tree warden, also a tree surgeon, showed up. He asked if he could continue to take care of the big tree out back. I think he was really inspecting us, to see whether or not we deserved the tree. He smelled of sawdust, had skin like bark, and obviously loved our tree, which he said was a White Oak, and the biggest tree in town. He said it was the only tree of its kind wider than it was tall, and that it was 400 years old. He lovingly cared for the tree for many years. Sometimes he came without tools, early in the morning, just to be with it. Years later, a friend said our tree was a Black Oak, and later still, another friend, with a field guide in hand, declared it to be a Red Oak.

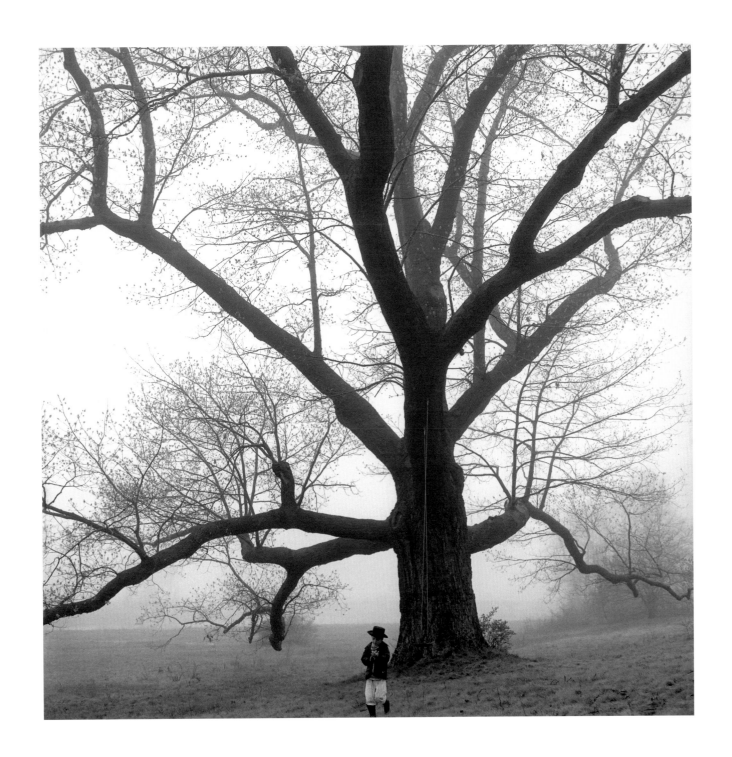

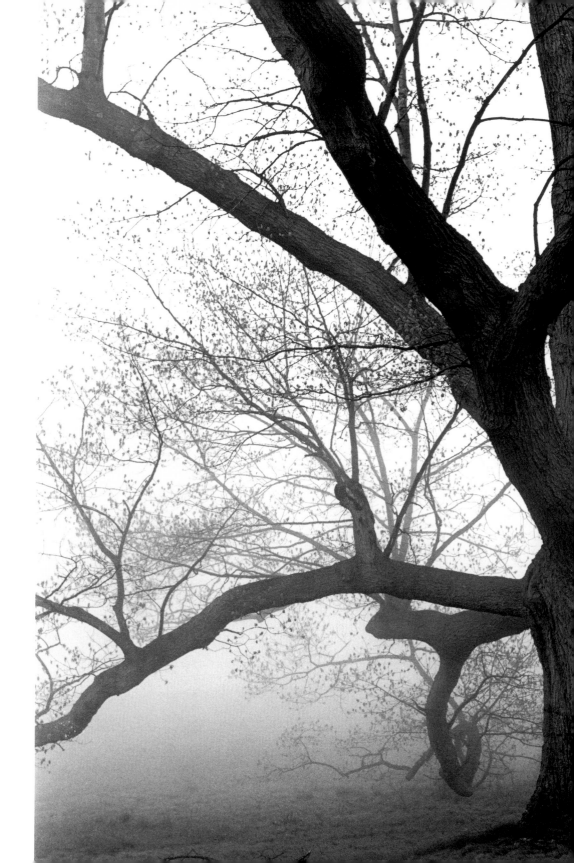

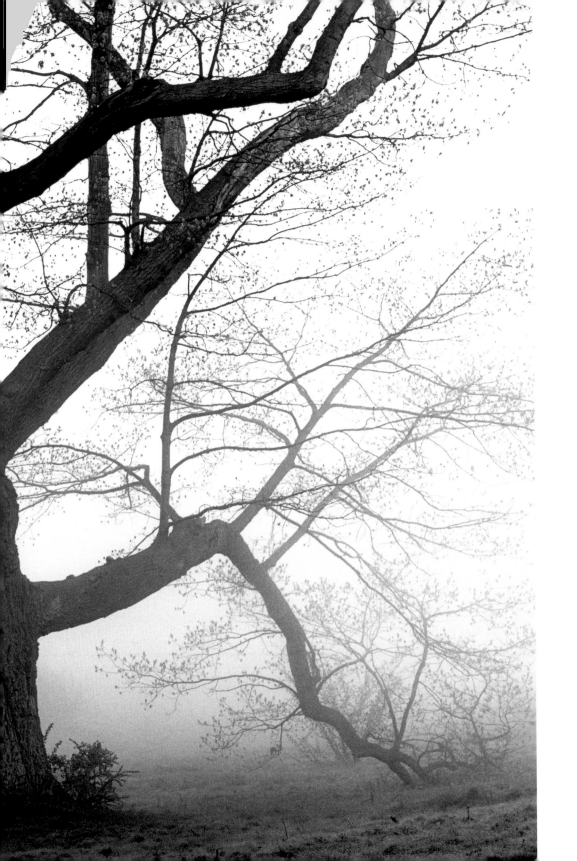

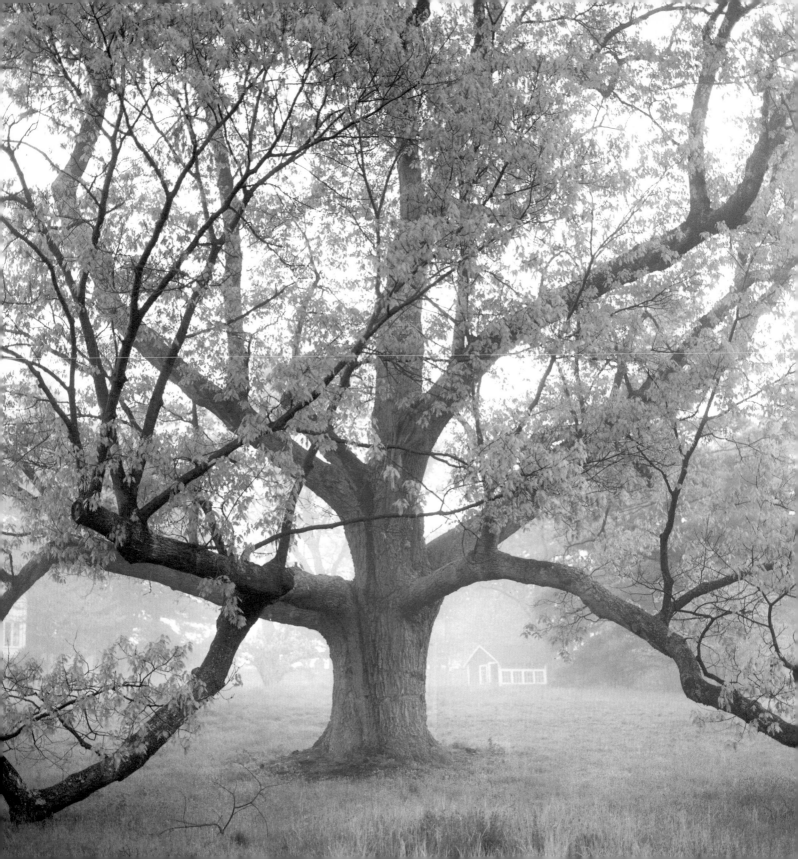

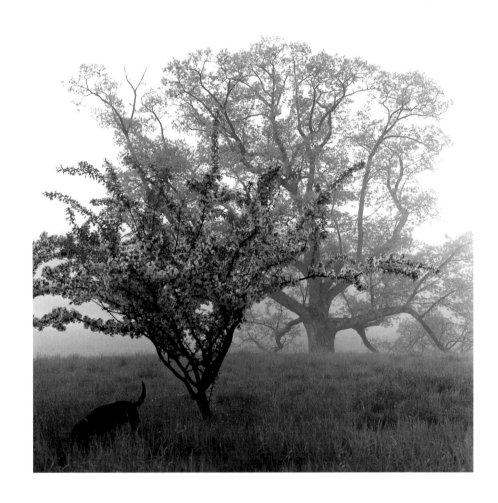

We never allowed the tree to be cored to find out its age. Exact measurements can lessen the magic. From the beginning, we suspected 400 years was a romantic exaggeration of the tree's age, but we were pretty sure it was present in the winter of 1775–76 when General Henry Knox and his men dragged cannons from Fort Ticonderoga on Lake Champlain down Main Street in Southborough on their way to General George Washington in Cambridge.

You could see the tree working on creatures passing by, including people-creatures. Children invariably ran or skipped up to the tree, while it slowed grown-ups down. Foxes trotting across the meadow would walk the shady diameter of the oak before trotting out the other side. Sometimes deer lingered under the tree on summer's hottest days.

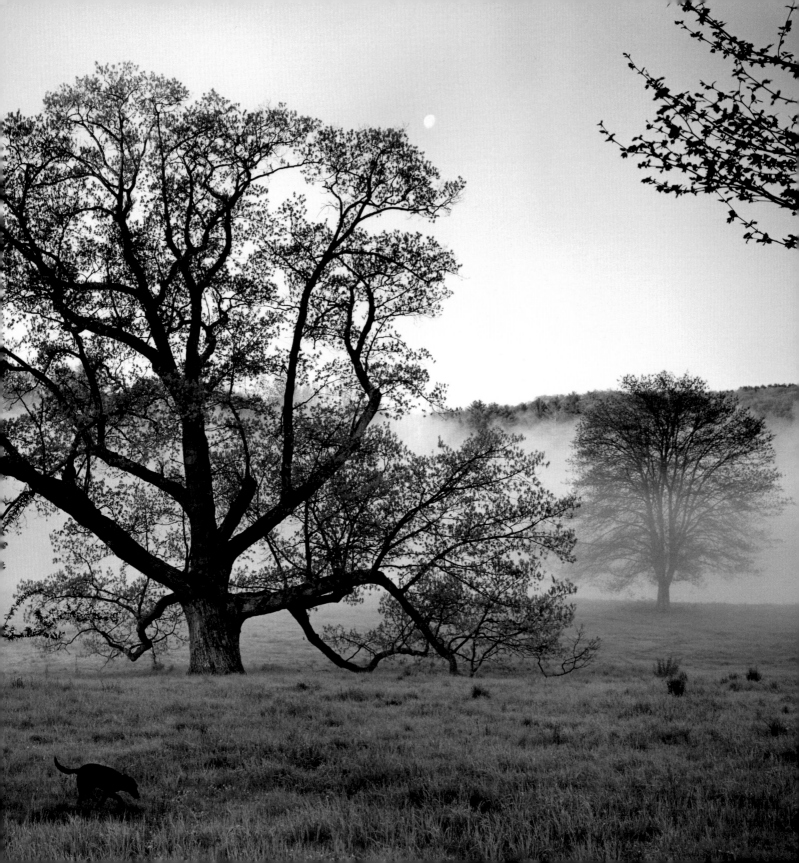

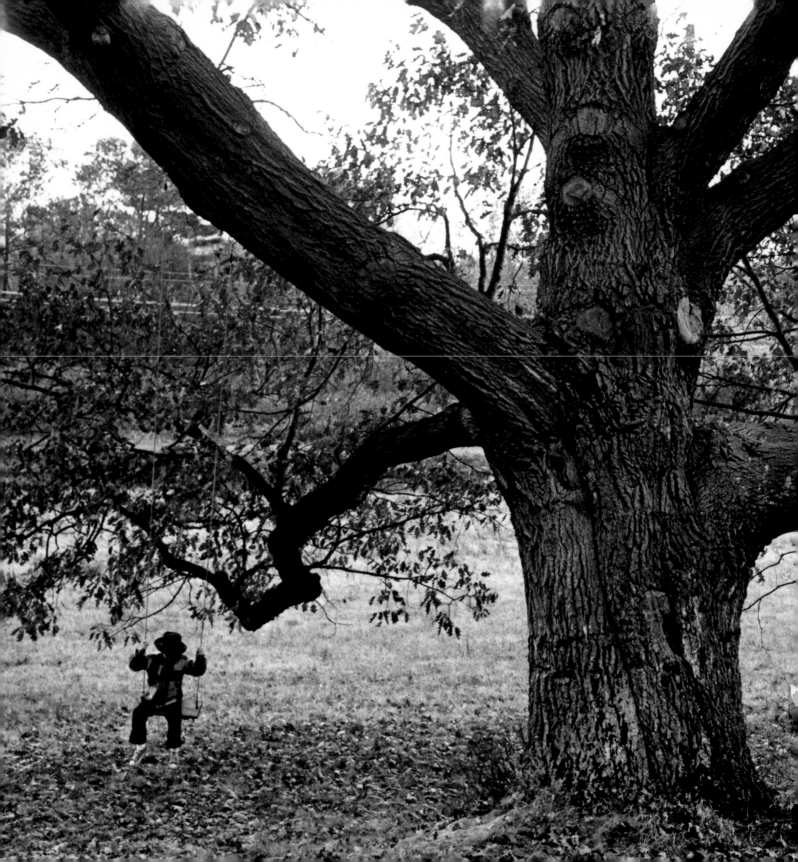

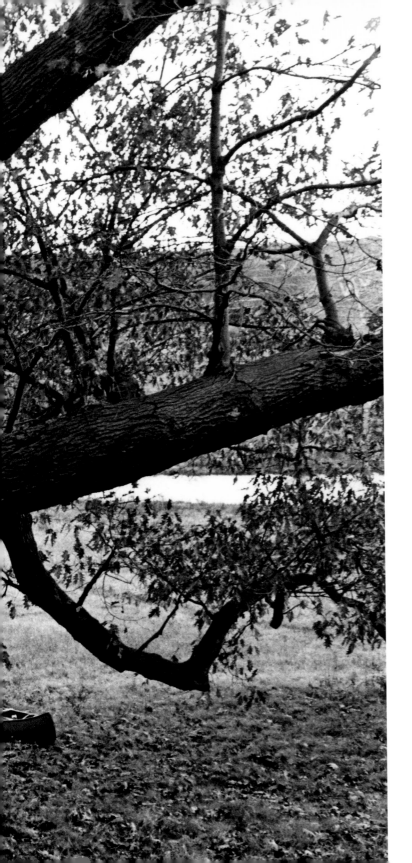

Each member of our family learned to put the tree to their own use. They went to it with friends, or to be alone. It was a popular place to do homework, or play the guitar, and it was our children's first campsite. All our pets, even the mice, are buried under it. A couple of dogs who moved away with their grown-up owners were brought back after they died, to be under the oak. Family members visited the tree before leaving for college or trips, and then again upon returning. While away, especially in winter, they'd inquire after the old oak, like they might after a favorite aunt or uncle.

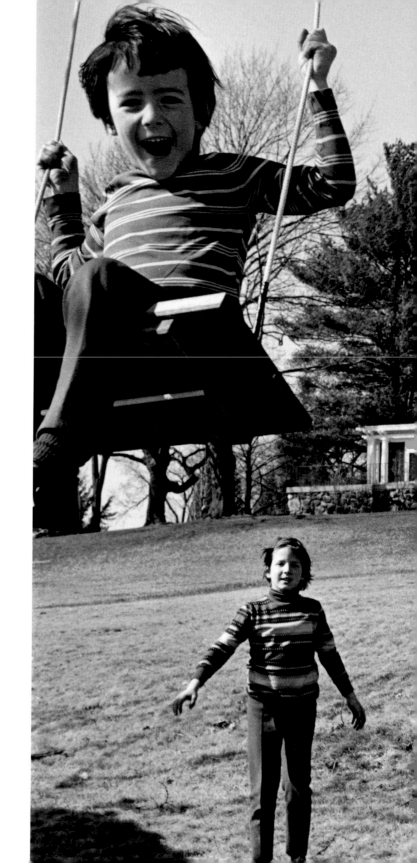

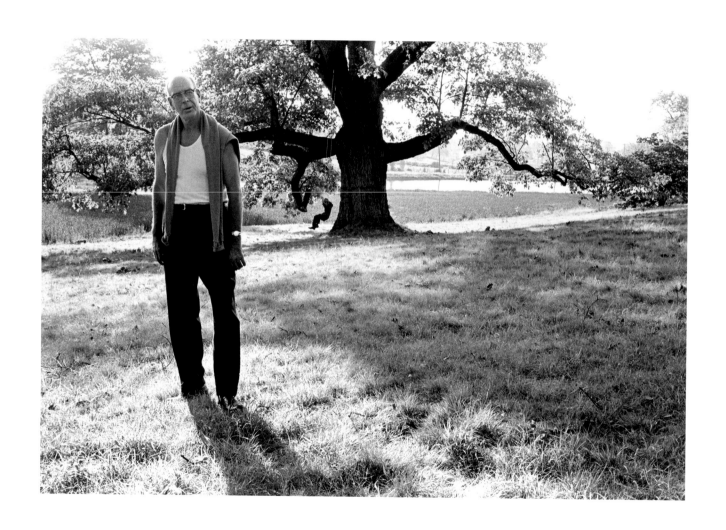

My father

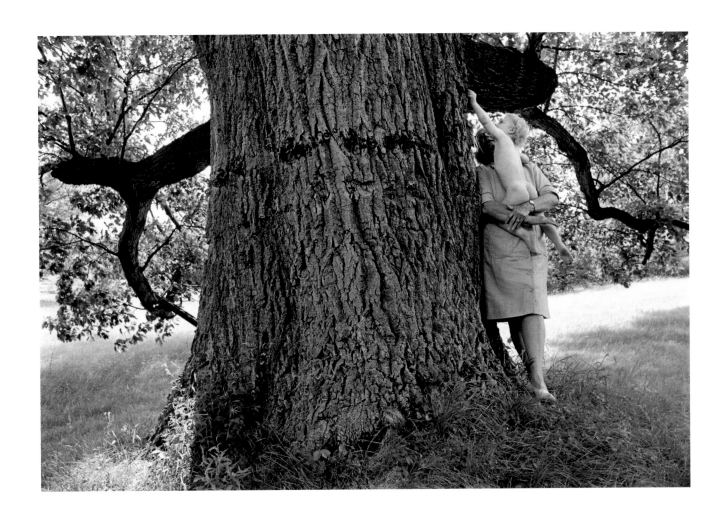

My mother

The tree centered my life and my thinking. When I was away from home, I would envision the oak and my family around it. That thinking was akin to fingering a smooth stone in my pocket for calm and solace. At home or away, I had what I called "oak thoughts." I'd mull things over in terms of the tree. The tree spoke to me of stillness, grace, patience, and determination. In our over-stimulated society, it was comforting to be with something grand and wise-seeming that got that way staying in one place. Twice when I had career choices to make, I checked my thinking by spending a whole night under the oak.

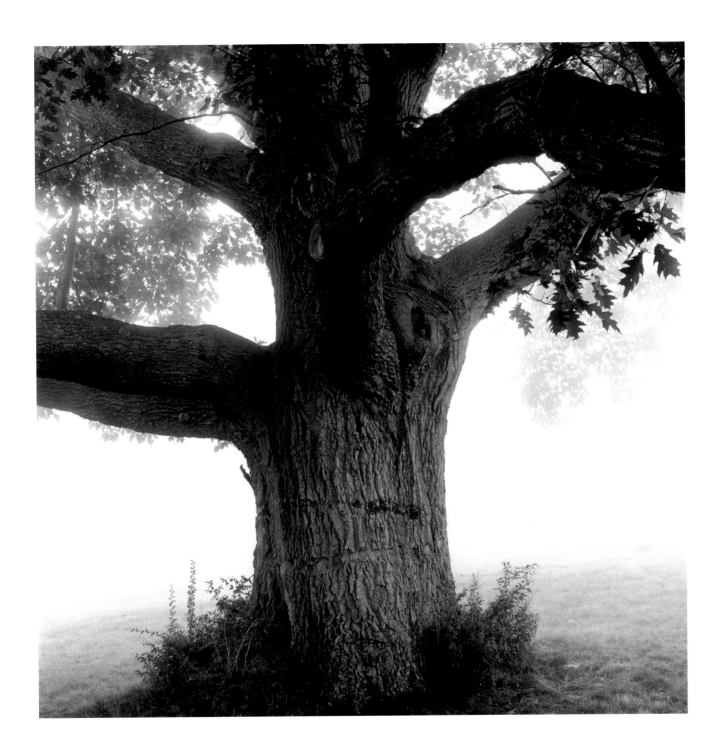

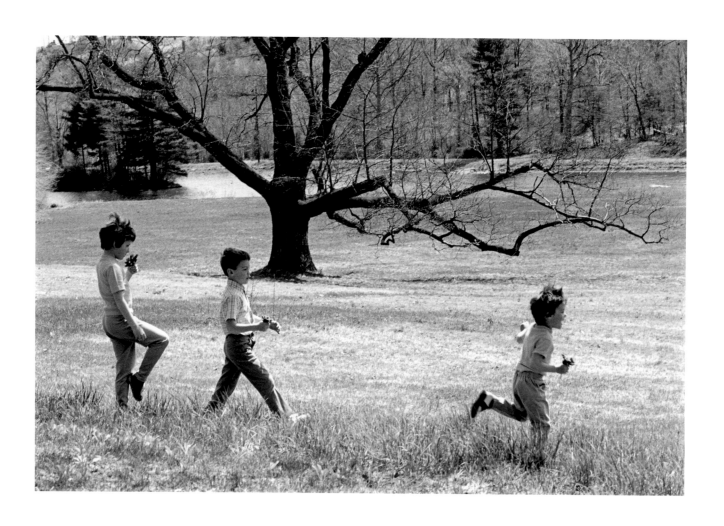

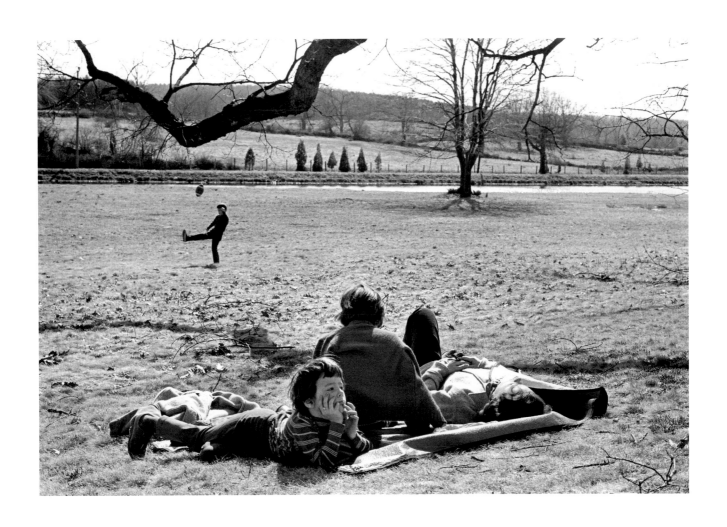

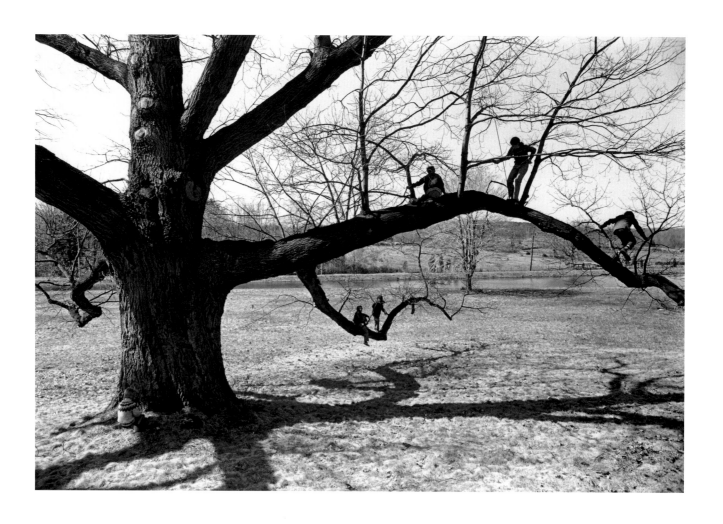

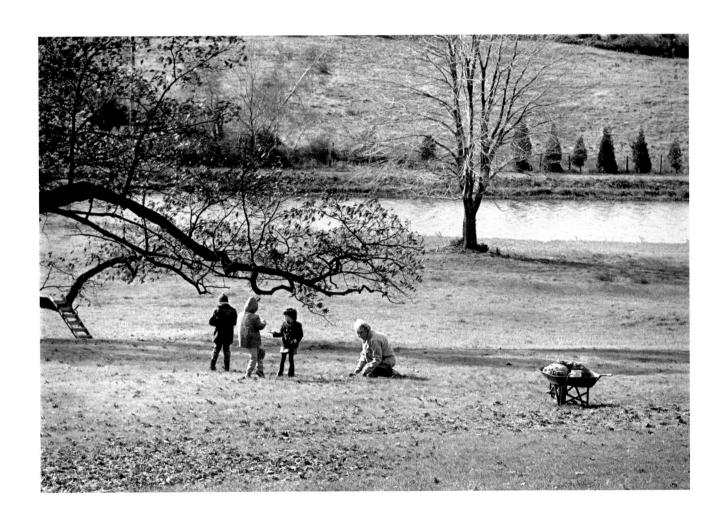

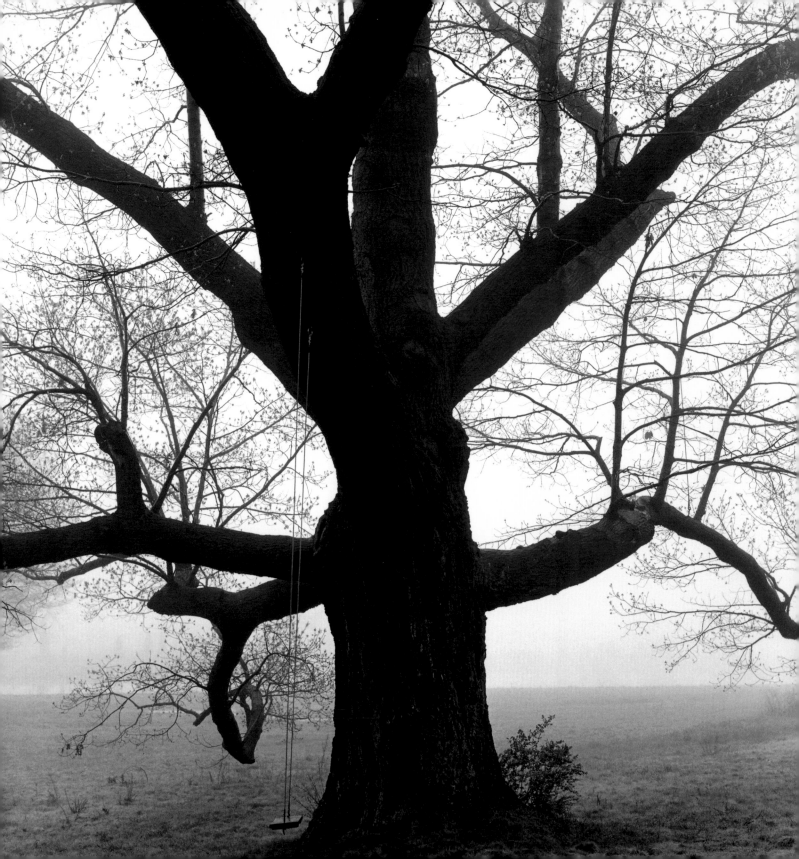

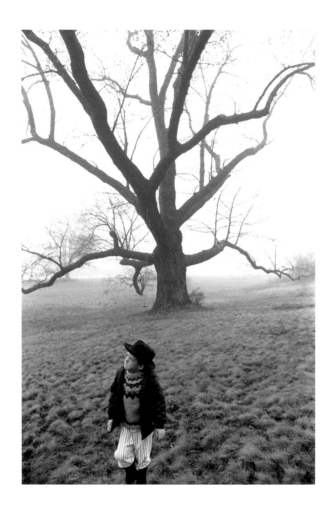

When our children were small, a Massachusetts newspaper held a contest
to find the largest tree in the state. The children were mortified when we didn't
win. They had been certain ours was the biggest tree in the entire world.

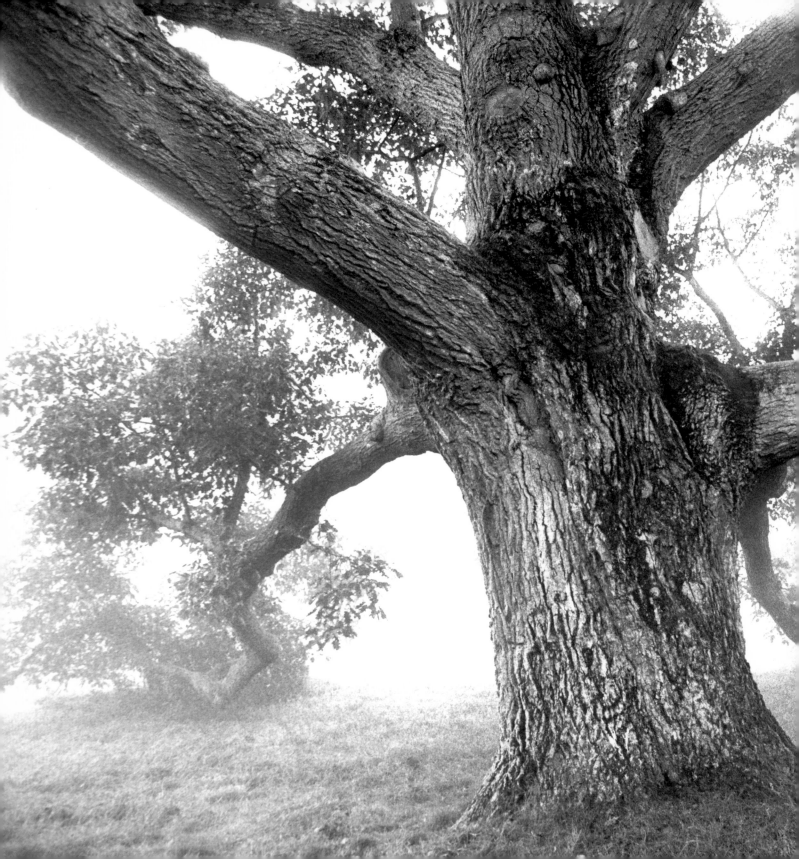

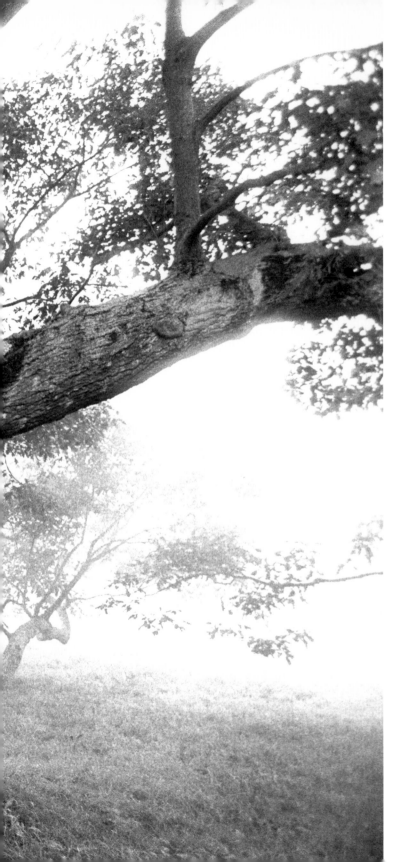

Though trees are considered stationary, our oak had an active look. It was compared to ballet dancers and lunging swordsmen. It looked ready, like it could spring suddenly into action, which passively it did constantly, becoming a living registration of every weather event to come down the valley, from zephyr to hurricane.

As a freestanding tree grows large, it becomes a world unto itself and a center of the local animal kingdom. It creates its own mini-climate and a system of interlocking communities. There is the life in the earth and among its roots, and in the grasses, and on the tree, and in it. The whole is crowned by the flowing, free-form community around and above it: butterflies, bats, and birds of all sizes, especially in times of migration.

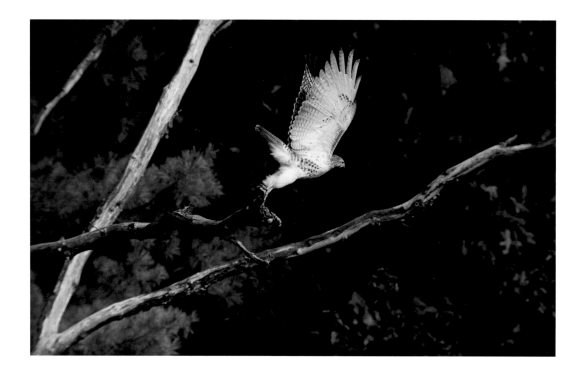

The oak was like a theater that always had something playing worth watching. Almost every year, Kestrels nested in a hole at the elbow of a high branch. Summer evenings we'd watch them hunting. Each year a batch of little raccoons was born somewhere in the tree. We'd see their pointy little faces showing through the pointy leaves of the oak. There was a nest of gray squirrels in a hole in the trunk of the tree, and a colony of honeybees used the same opening. Garter snakes raised their young in a crack at ground level. In winter, under the oak was a perfect place to study animal tracks. Year-round, Red-tailed Hawks hunted out of the tree by day, and regularly, by night, Great Horned Owls took over. On damp, early summer evenings, it could be like a cave under the oak, and at times it would be illuminated by fireflies.

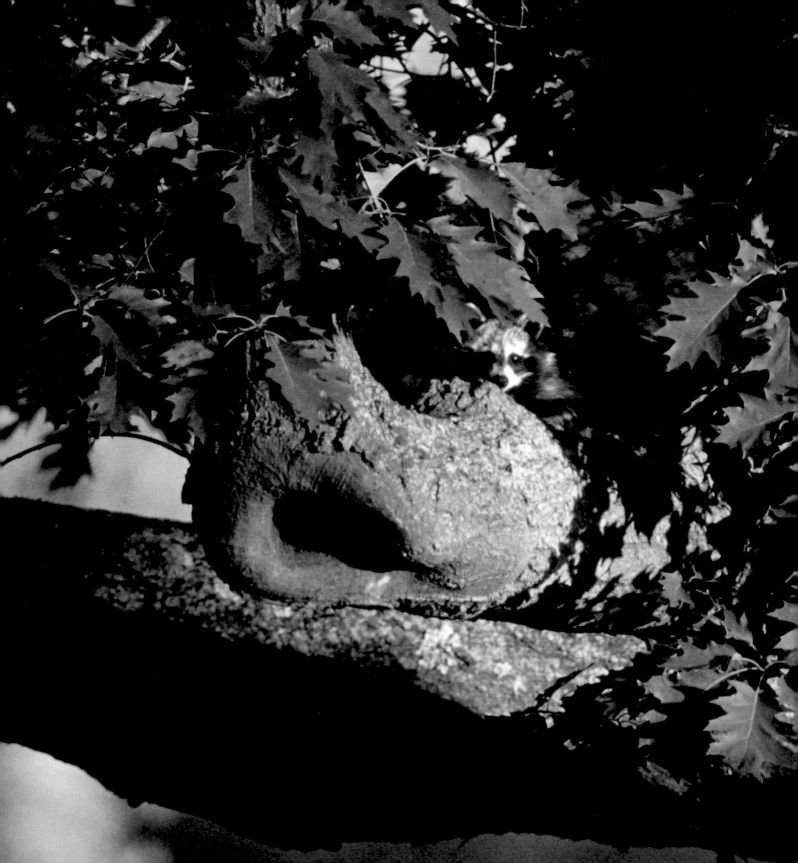

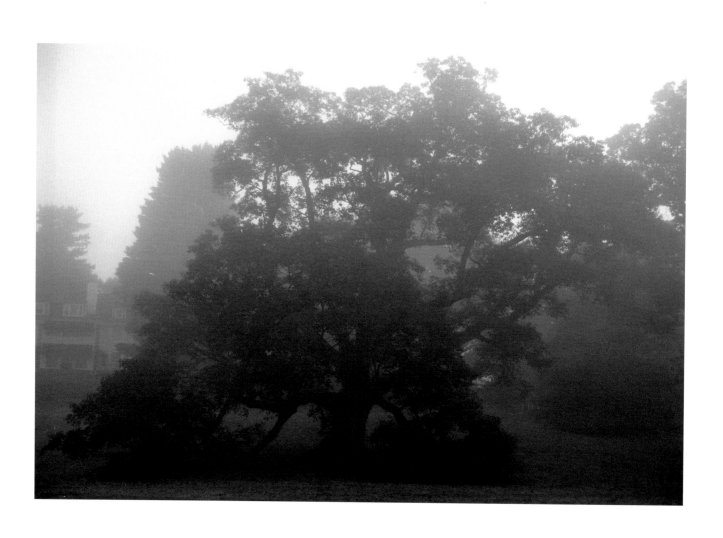

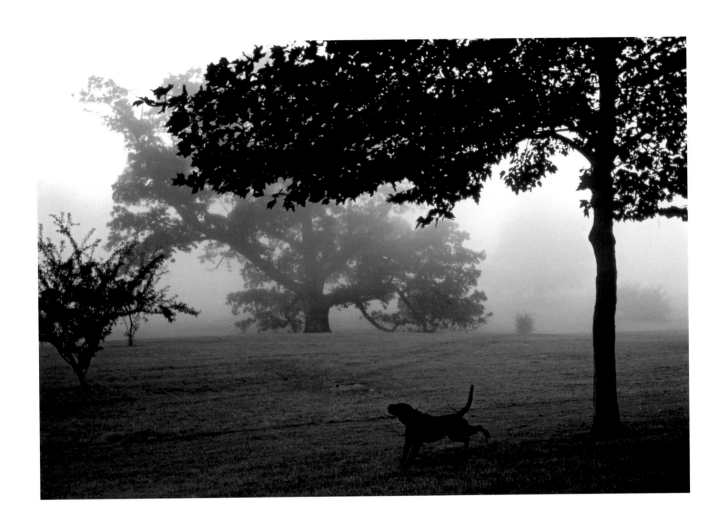

We know that our neighborhood was forested in Colonial times, yet our tree was given space and time and light and water to fulfill whatever dream-design was within it. And it was protected by what our children called the "soft hills," dug out over time by Stony Brook. I assumed at first that our tree had been allowed to live while its neighbors and siblings were cut down, because everyone who encountered it saw that it was beautiful and worth saving. But I think, really, it was ignored over the years because for human purposes it was useless. Too twisted to become a spear or fencepost, and too heavily knotted to be made into lumber. As the countryside changed from forest to farmland, perhaps the first person to recognize its value was a farmer whose cows took refuge in its shade on hot days, and who sheltered himself and his team in a downpour. In my mind's eye, I see his family gathered under the oak for a Sunday picnic, the children skipping stones on Stony Brook and turning over rocks in search of crawfish.

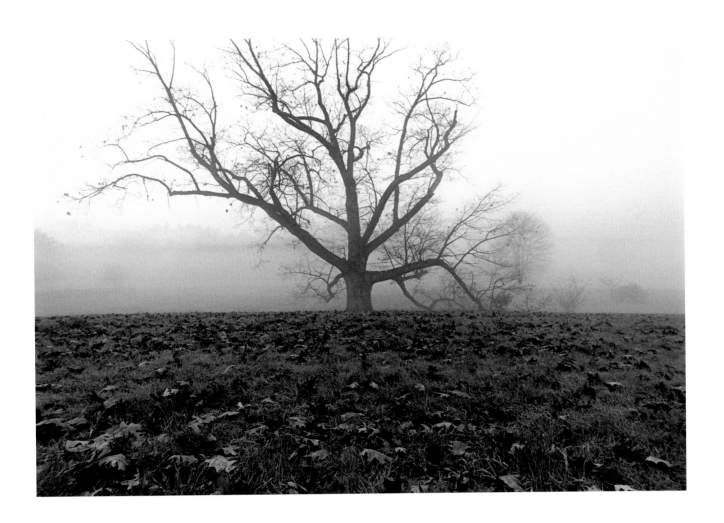

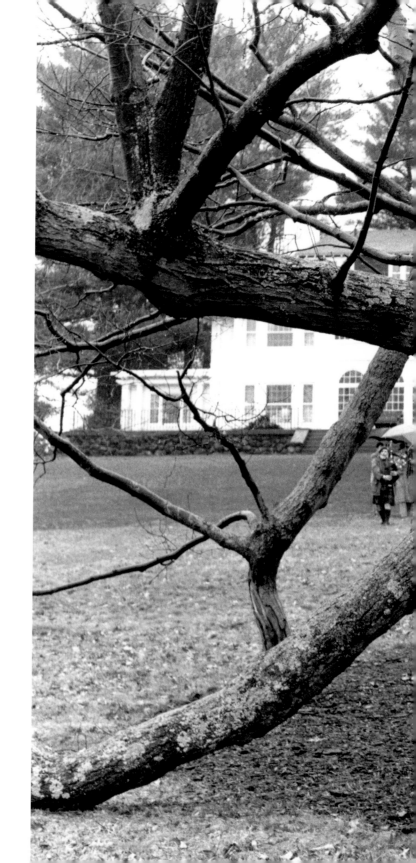

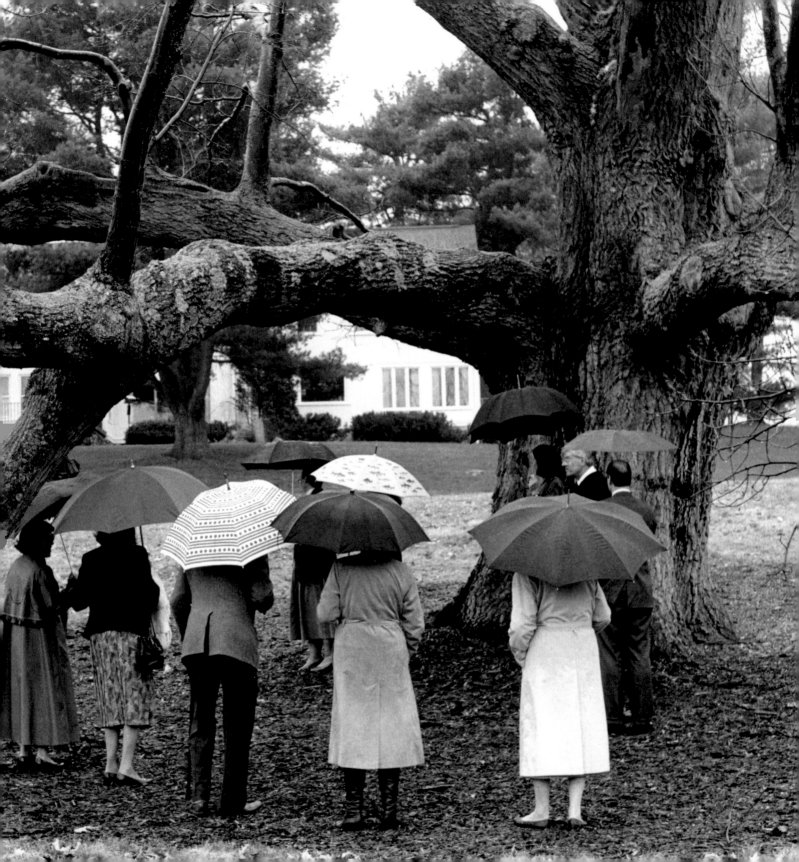

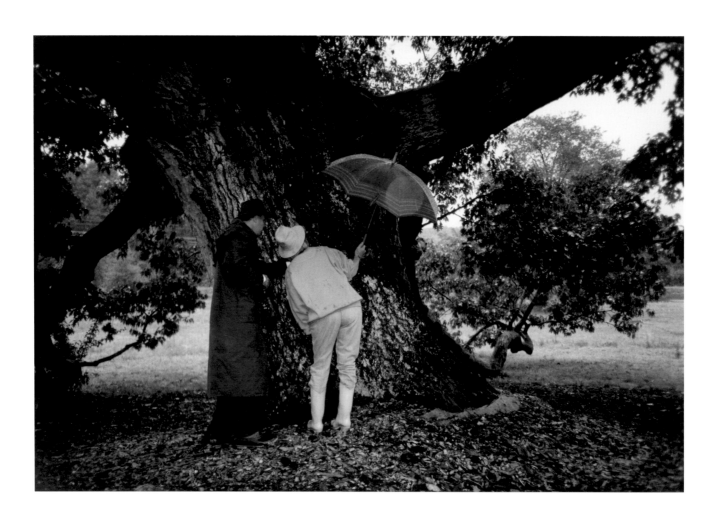

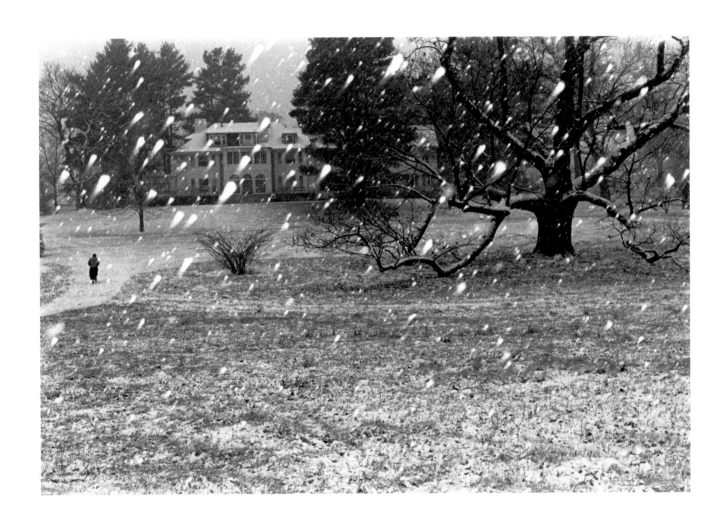

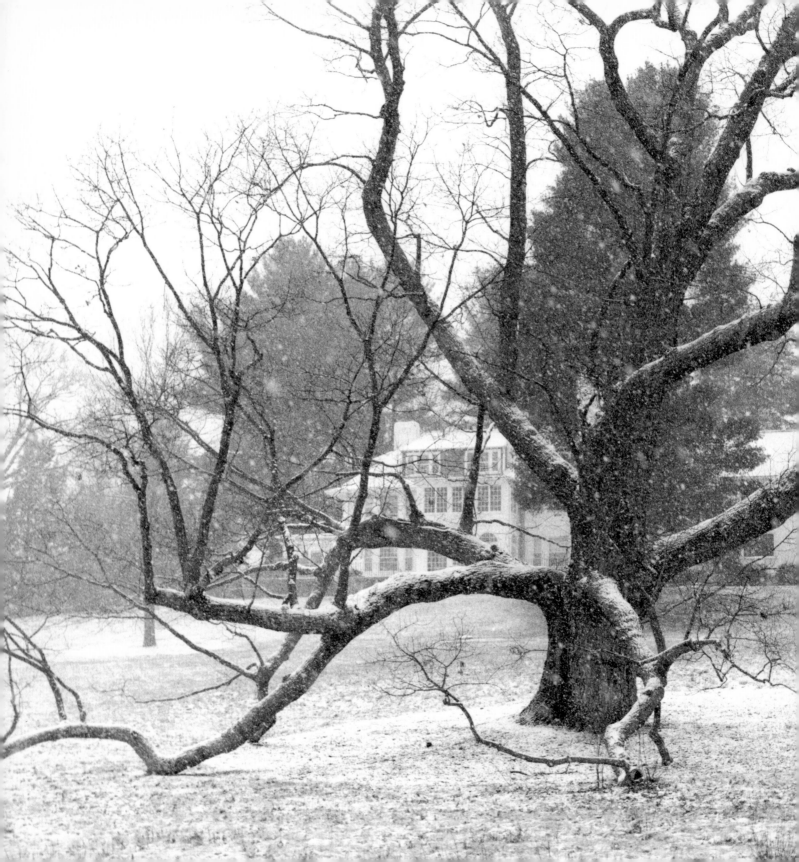

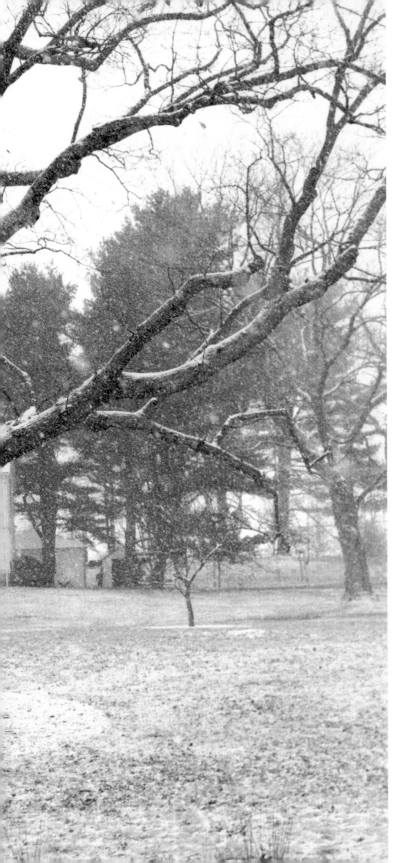

There was clear evidence, in the form of supporting cables and cement-filled cracks and crevices, that the original owners of our house admired the oak. They also left photographs of the tree, taken when it still had a youthful look.

A good place for a big tree isn't always a good place for an immense tree. After we'd been in Southborough for a few years, one after another of the great lower limbs settled and touched the ground, making it seem impossible that it could ever fall over. About this time, huge platter-like funguses began growing underneath the tree, a dramatic and slightly disgusting manifestation of rot in the root system. To take pressure off the tree, we cut holes in its "sail," that expanse of foliage a tree presents to the wind. And we placed cables in the tree for support.

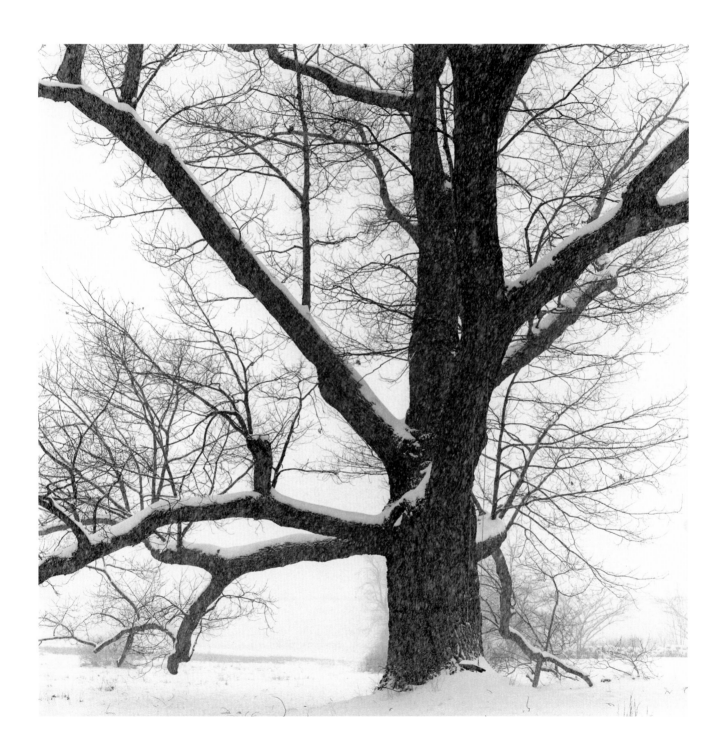

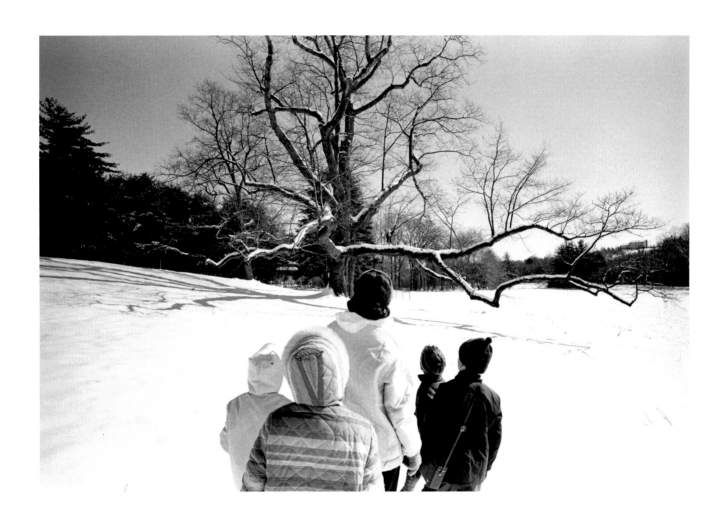

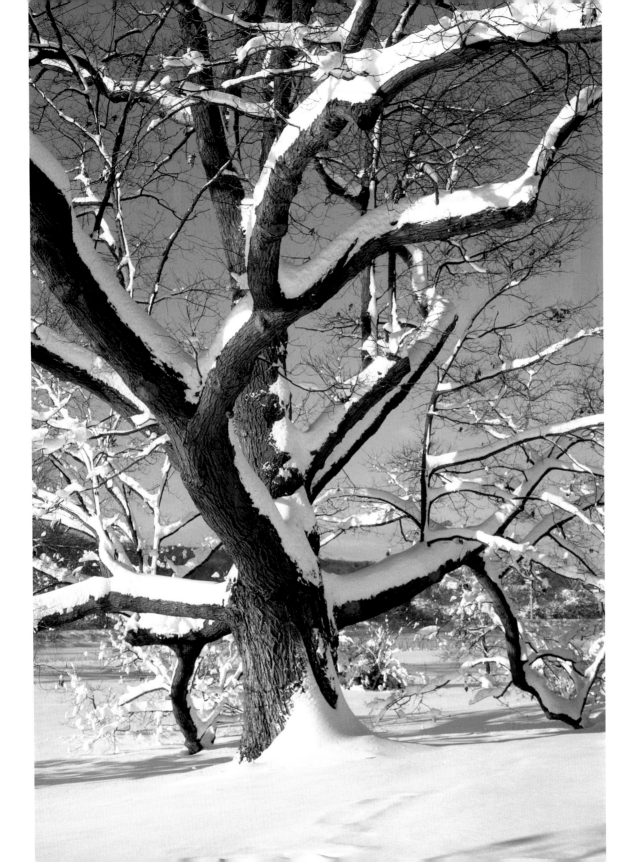

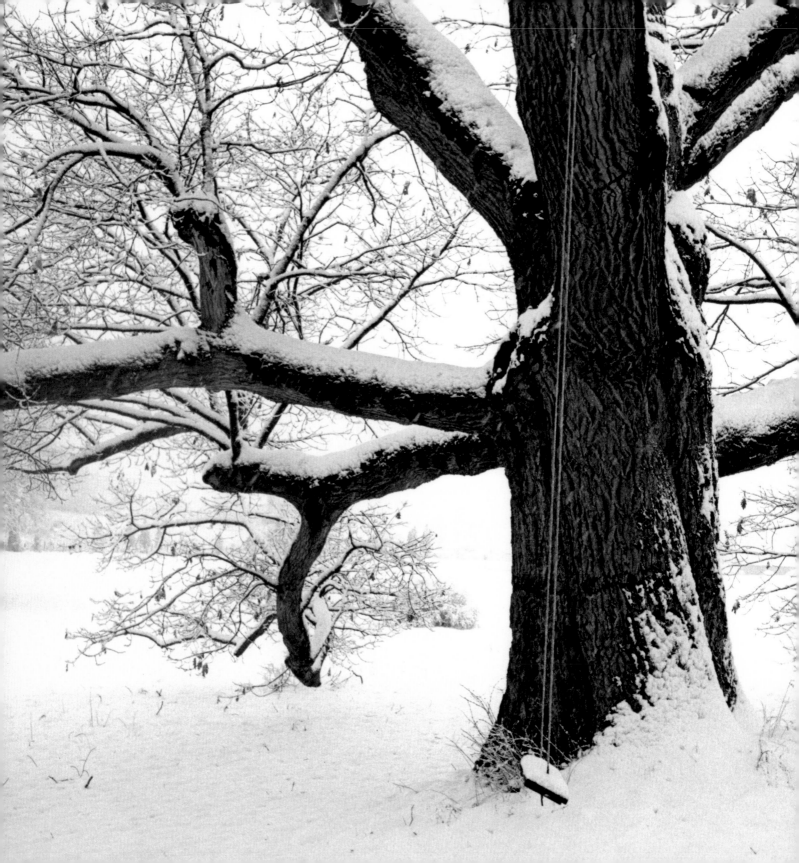

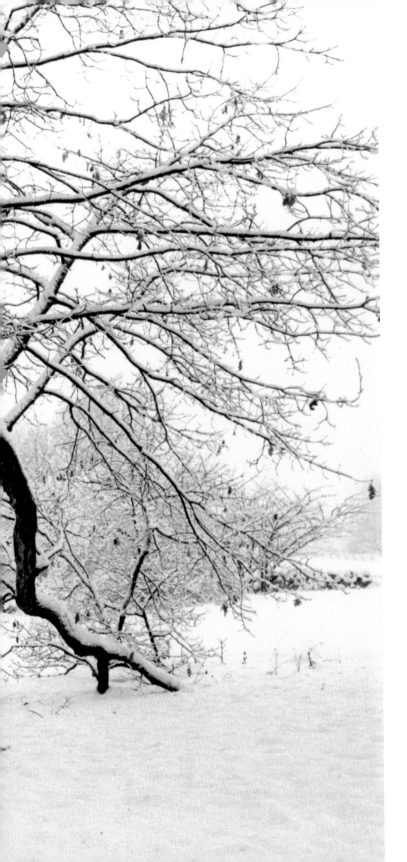

Every species has a dying age, the average age when members of that species die. But when remarkable individuals get past that age, they can go on for a long time. Sometimes people would ask, "Whatever will you do without that tree?" But we were confident our tree would still be standing long after we were gone. The oak's problems didn't seem to us like diseases, but more like badges of honor, emblems of long life, each problem having its own charm and value.

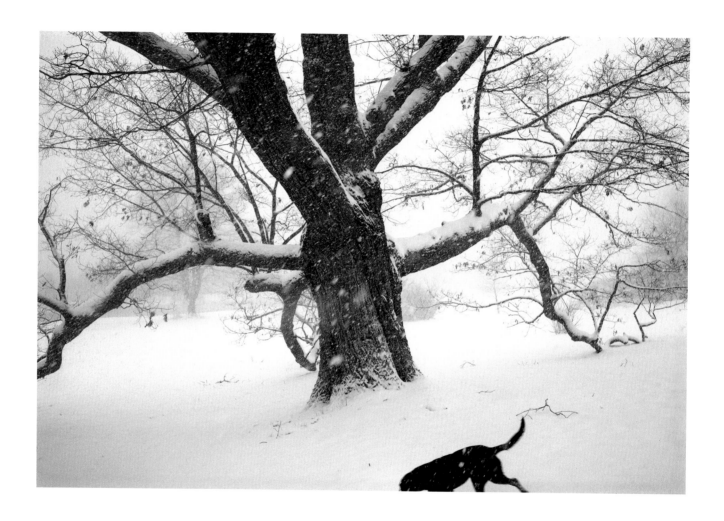

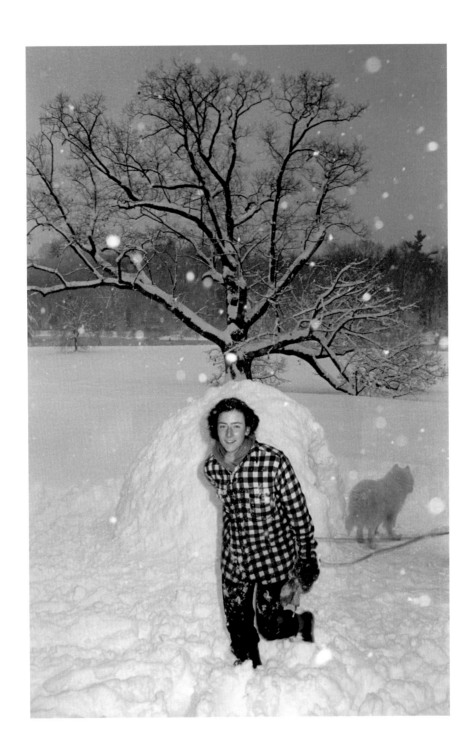

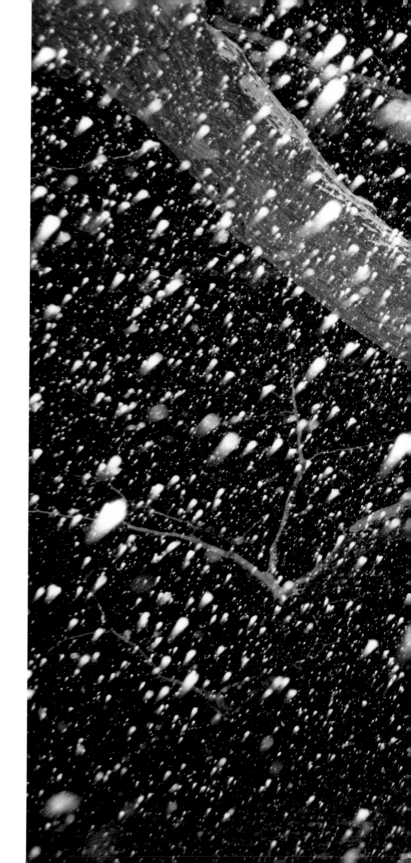

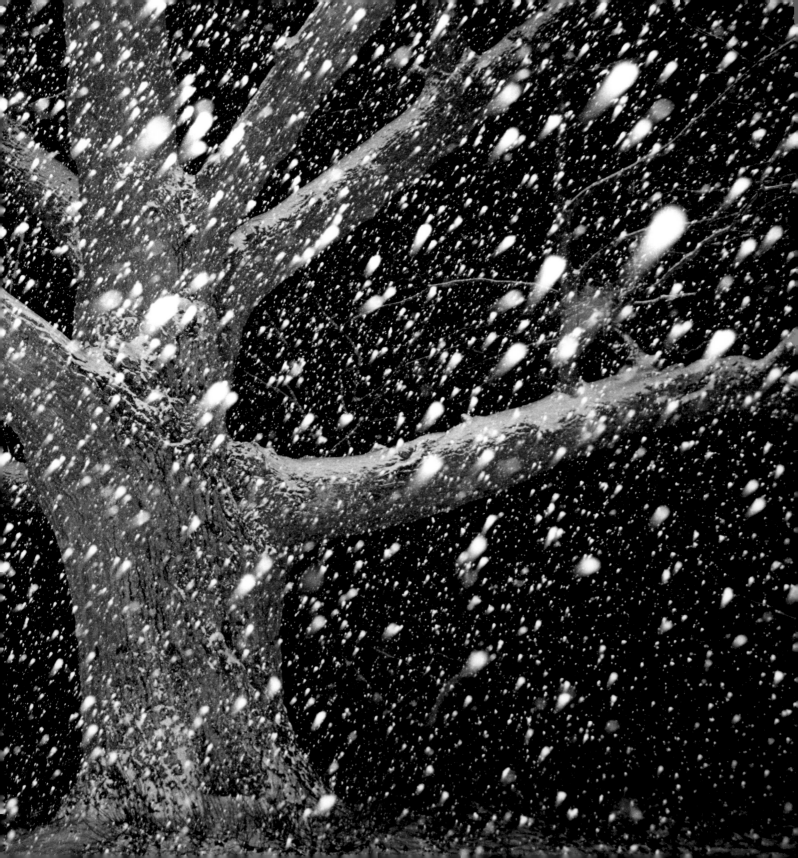

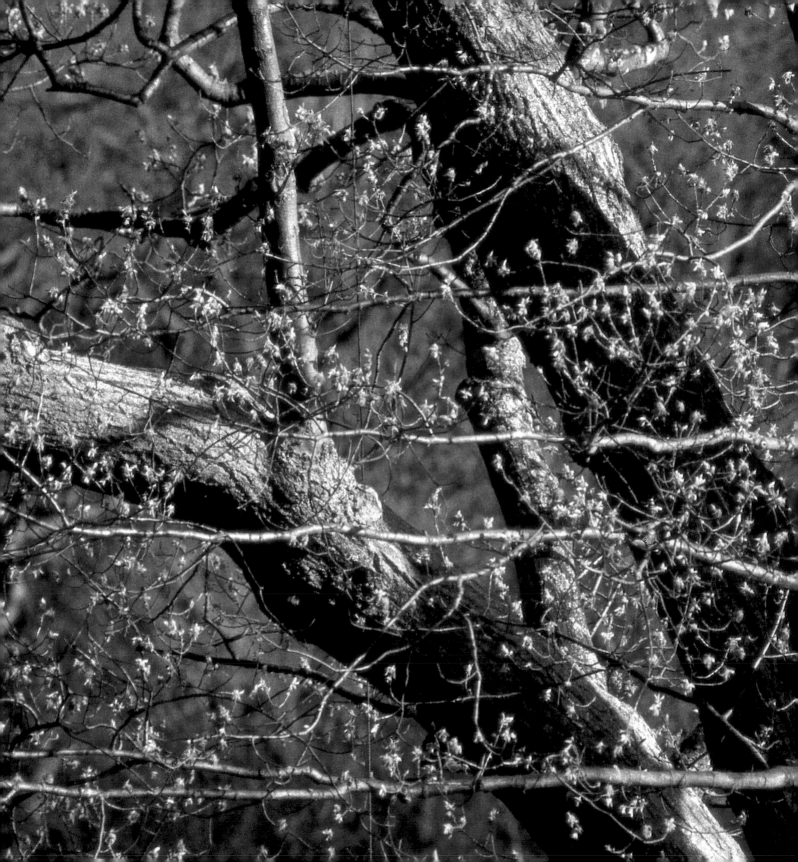

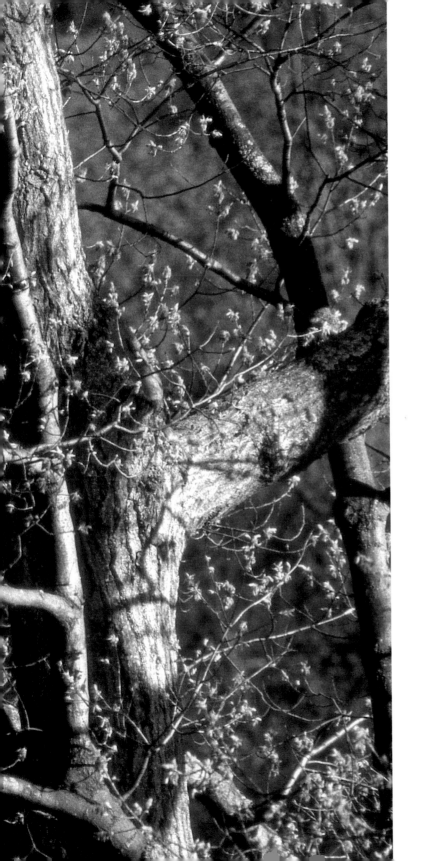

In the spring of 1981, a plague of Gypsy Moths hit New England. Our oak was almost fully leafed-out when it arrived, and by June's end it was as bare as in December. By mid-August, it was covered with small, pale leaves. We knew we'd seen a miracle, but worried about the effort it took to bring it about.

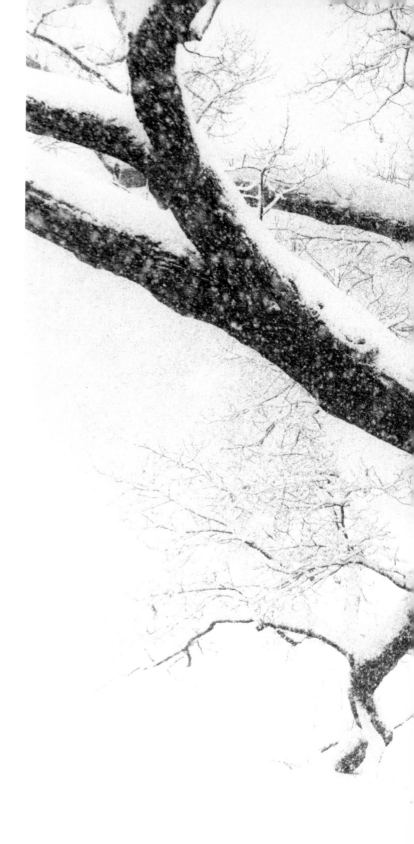

As time passed, we noticed that the oak had started to lean slightly eastward. We weren't concerned about its toppling, because it had limbs that touched the ground and seemed to support it like flying buttresses. But when a tree surgeon suggested we put a cement block in the ground with a cable running to its top, we listened. We thought it was understood that work on the oak was to be done only when we were at home. But on September 21, 1995, while we were in Maine, this procedure was carried out. The next day a neighbor called to say our tree was down.

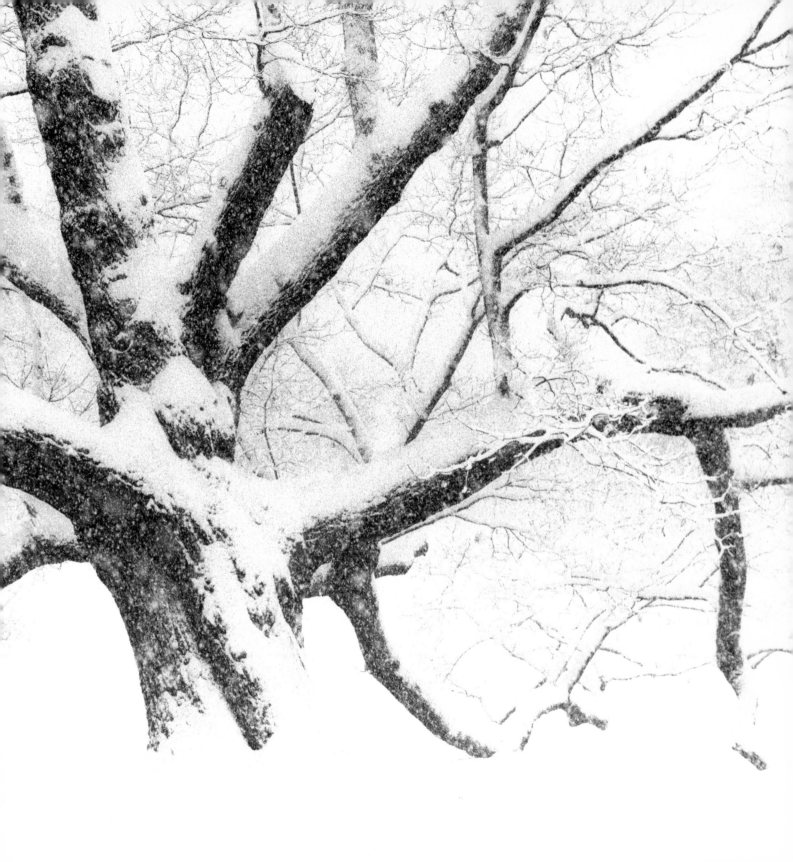

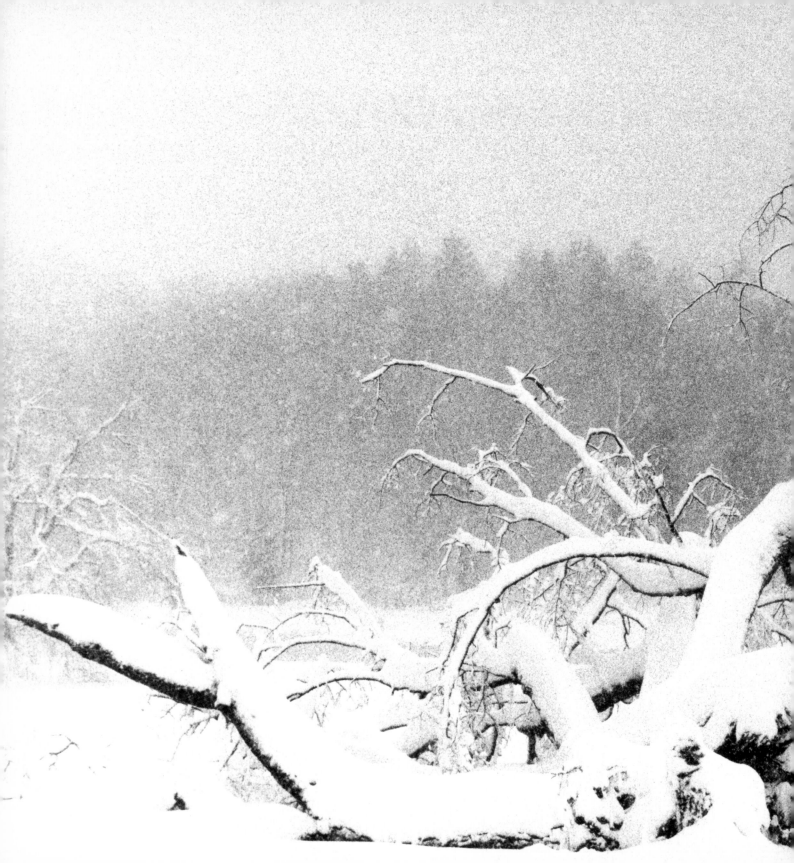

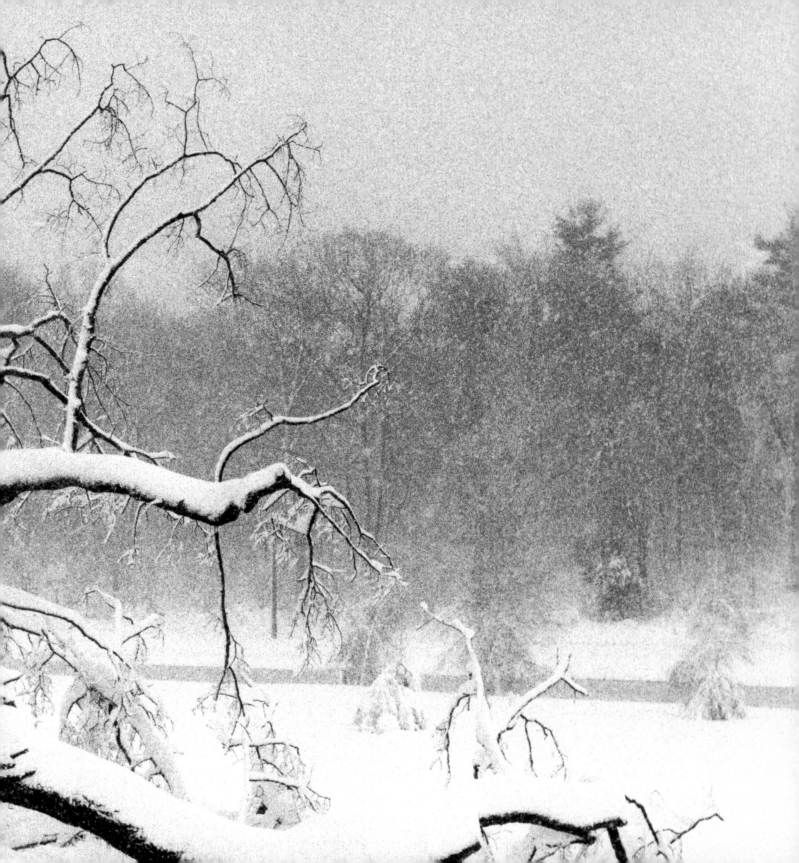

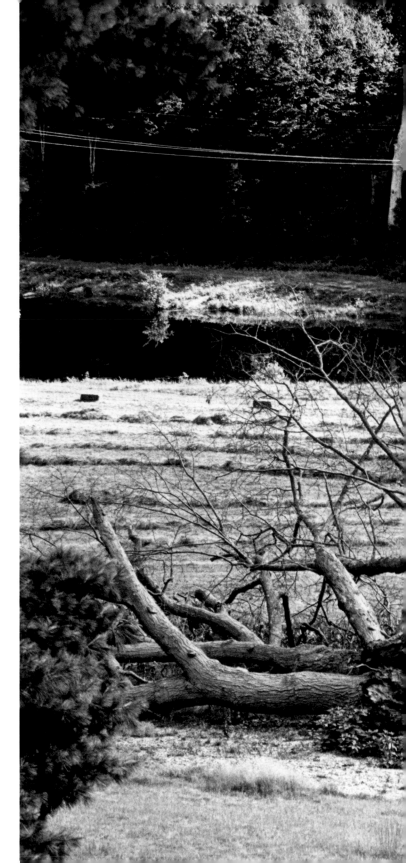

The sadness we first felt at seeing the tree lying down was curiously softened by how interesting the scene was. The tree seemed bigger than it ever had. And it was covered with exploring children and ringed with adults, many of whom we'd never seen before. A disaster becomes everybody's business. You could see how excited the children were to get to the tree by the way they'd abandoned their bicycles, willy-nilly, all over the place. We heard a granny say to her grandchild, "Remember *Gulliver's Travels*? The tree is like Gulliver." Over time the tree was compared to a rock pile, an elephant, a hippopotamus, a dinosaur, and an octopus.

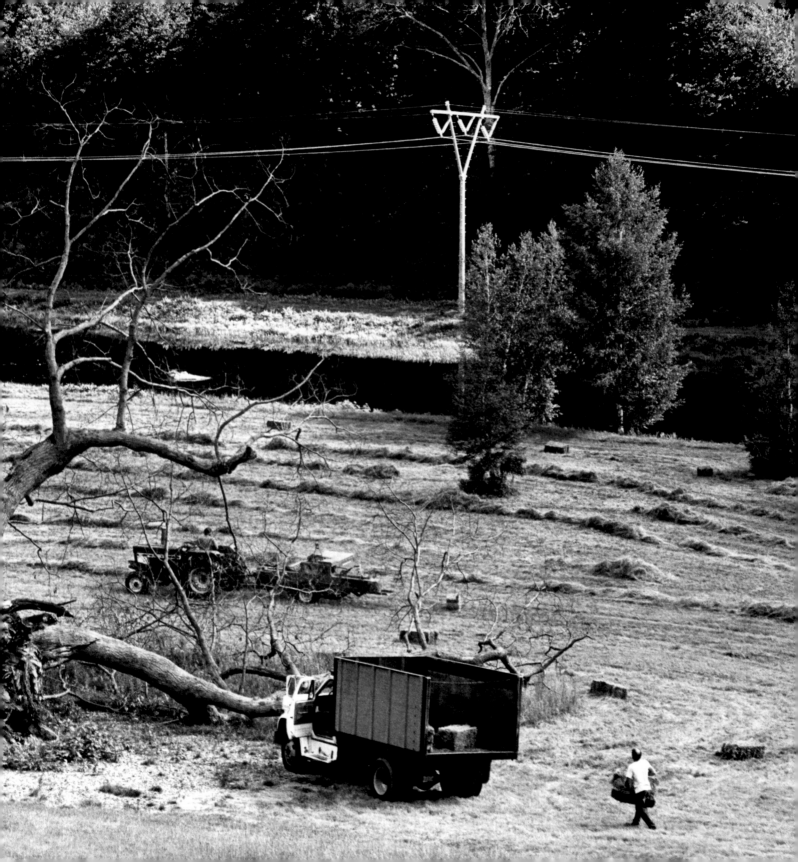

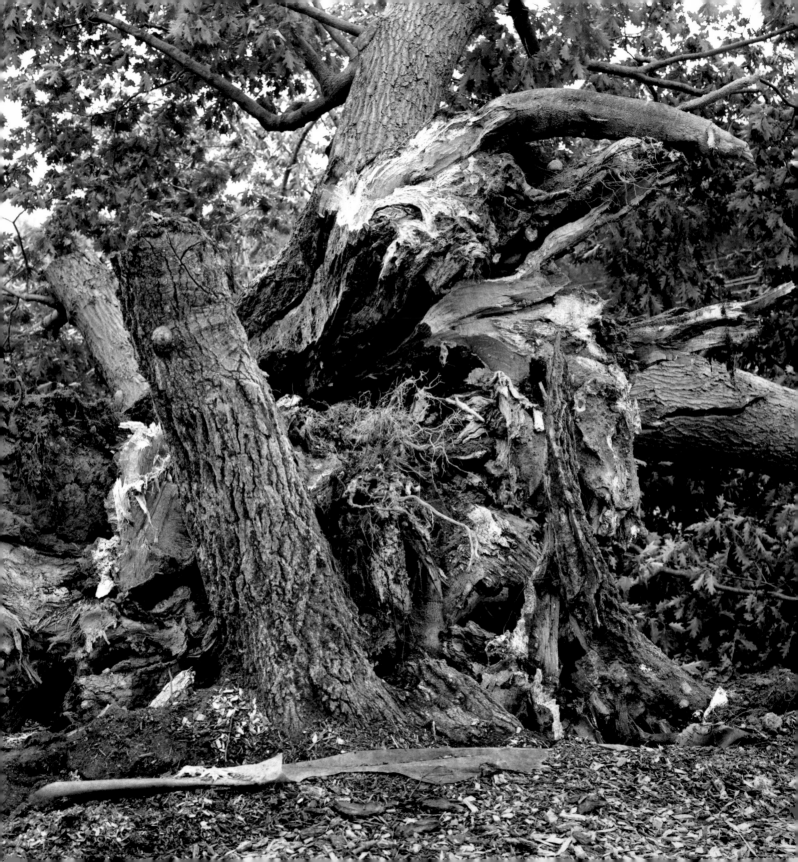

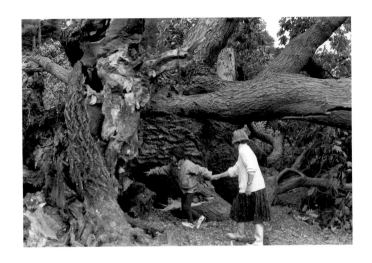

I wondered what the tree sounded like when it came down. No neighbor was able to tell me. I imagined it falling on its knees, so to speak, sliding onto its side, then rolling onto its back. And I suspect the whole process was slow and grand, accompanied by unique and amazing sounds. Once, in Maine, a large wooden trawler loaded with surf clams became grounded on Ogunquit Beach. The skipper figured he could work it off the sand on the next tide. He couldn't. Over the next few days and weeks, the ship wallowed, settled, and split open. The oak acted like that ship in the following months and years.

When the oak was full of its own life and shining, I'd sometimes imagine what it would be like to stand among its highest branches. When it fell over, of course I could do that. But instead of giving me a view of the countryside all around, I could appreciate, maybe better than ever, the great reach and volume of my old friend.

I knew I had photographed the oak from time to time, but the day I saw it down, I wished I'd photographed it "on purpose," with the intention of telling its story. I didn't realize at the time how many pictures I had of the tree.

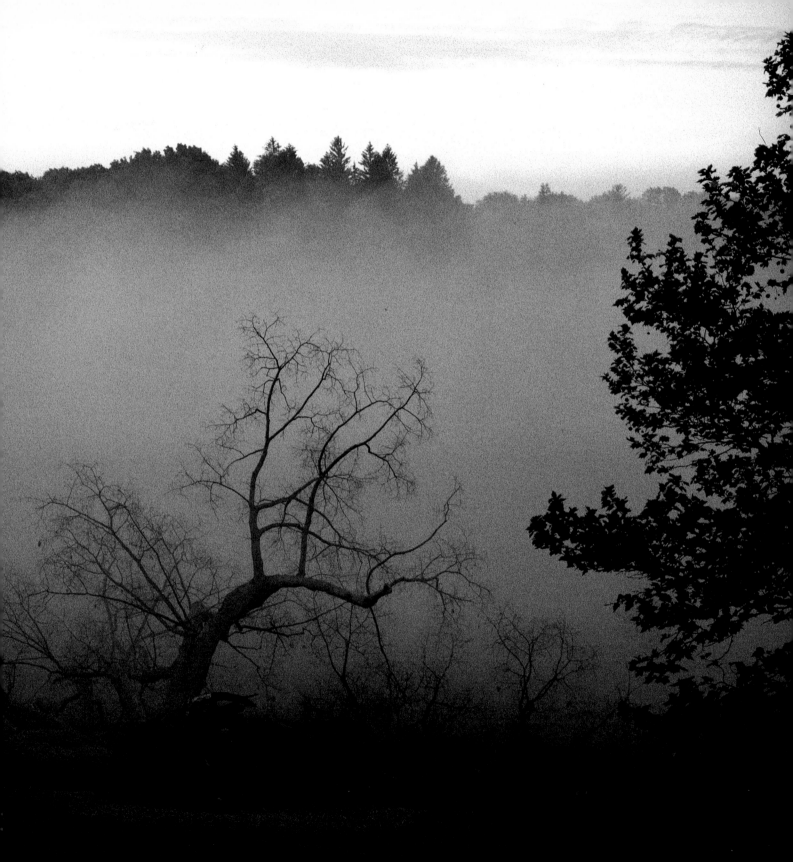

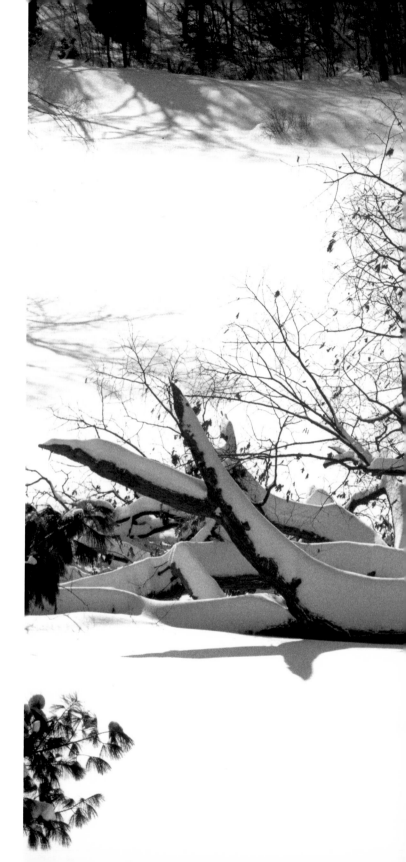

For a couple of winters we hoped in vain that a few green shoots would appear from the oak's roots or stump. Finally, we admitted the tree was dead, and began thinking about cleaning up the backyard. We located a sawyer with a portable mill who would come to our tree so we could dismantle it carefully. We planned to make a new front door for our house, a sacred table, and boards to give to family and friends. Then, one morning at breakfast, Judy said, "Why don't we just leave it?" I felt instantly she was right, and we decided to let it be, let it follow through on nature's and its own terms. And so it entered, in some ways, the most generous phase in its existence. No longer directed by its own will, it became a general resource, which any life in the neighborhood was free to put to its own purposes.

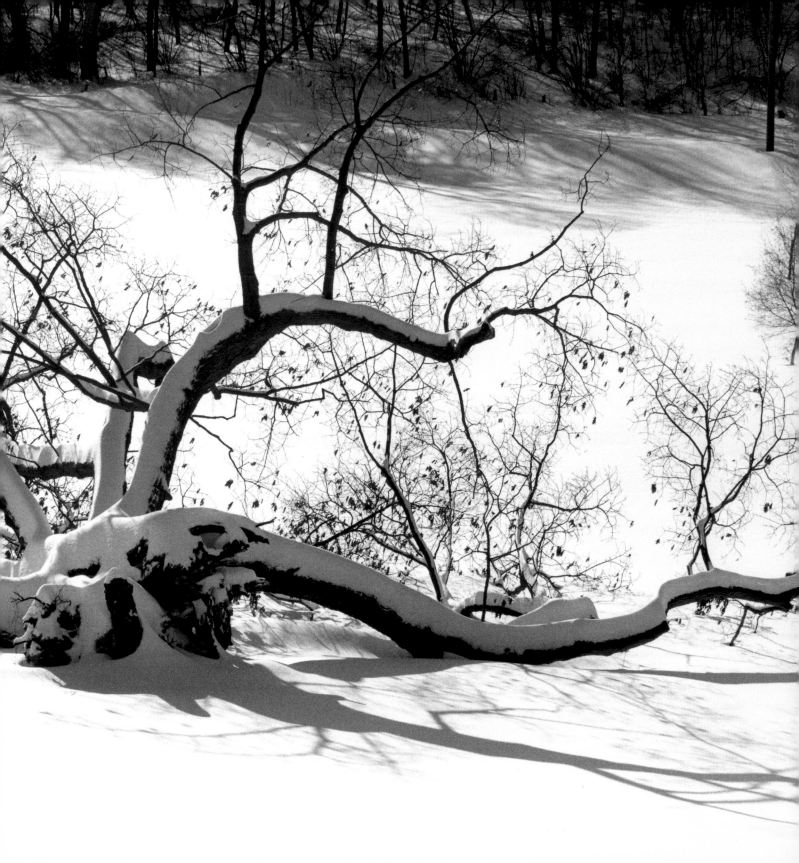

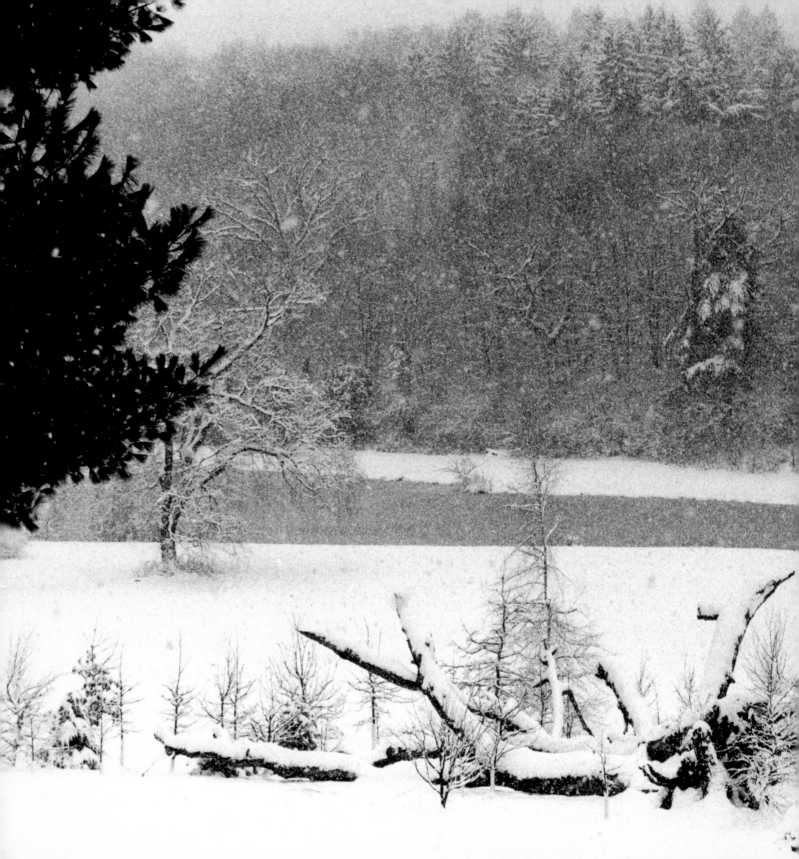

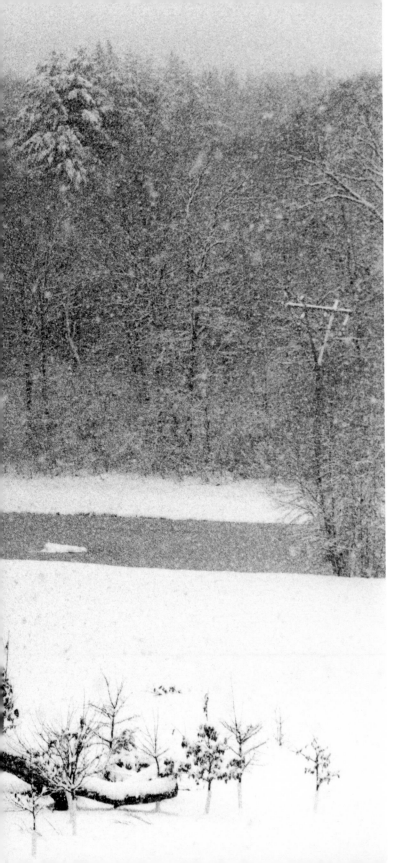

By now, the tree was surrounded by a tangle of bushes, soft plants, wildflowers, and brambles. We hoped that underneath this jungle there would be a few seedlings, perhaps a few Red Oak seedlings. As we tidied up around the tree we found a profusion of saplings. The first few winters we lost some to moles, voles, and cold. But many survived, and the uncomfortable work began of choosing which little trees would stay and which would go. We were guided by what worked for the great oak. We tried to give each small tree the space needed to become itself.

At a talk I gave about the oak, a lady asked if I had felt any relief for the tree when it fell down. When I said I hadn't, she said that the tree had lived a long time and deserved to rest. I felt embarrassed because I'd been thinking about my own desires only. In tree terms, maybe it did experience relief. In any event, it certainly is having a dramatic afterlife.

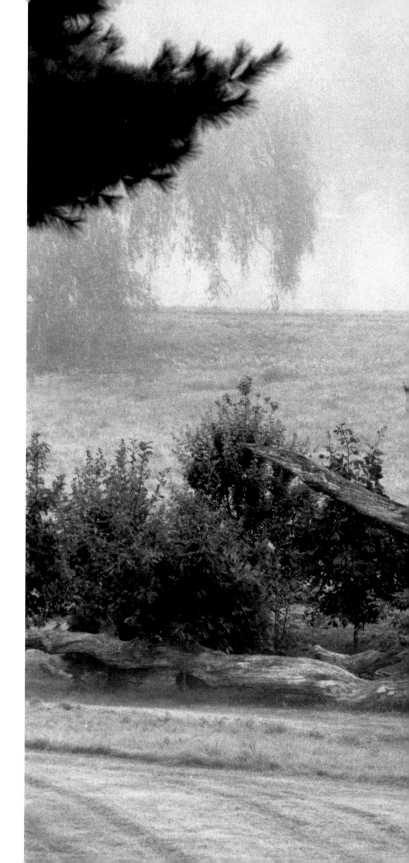

It's now eleven years since the oak came down. It was once a "difficult parent." It required so many nutrients, and cast so much shade, that no youngsters could live long in its company. Now its huge hulk lies in the midst of a new little forest, like a great sow suckling her progeny. The oak's bulk protects the small trees from the elements, while its steady disintegration feeds them. Visitors ask from which nursery we purchased such a variety of pretty little trees. But they are all volunteers, come by the agencies of birds, animals, and winds.

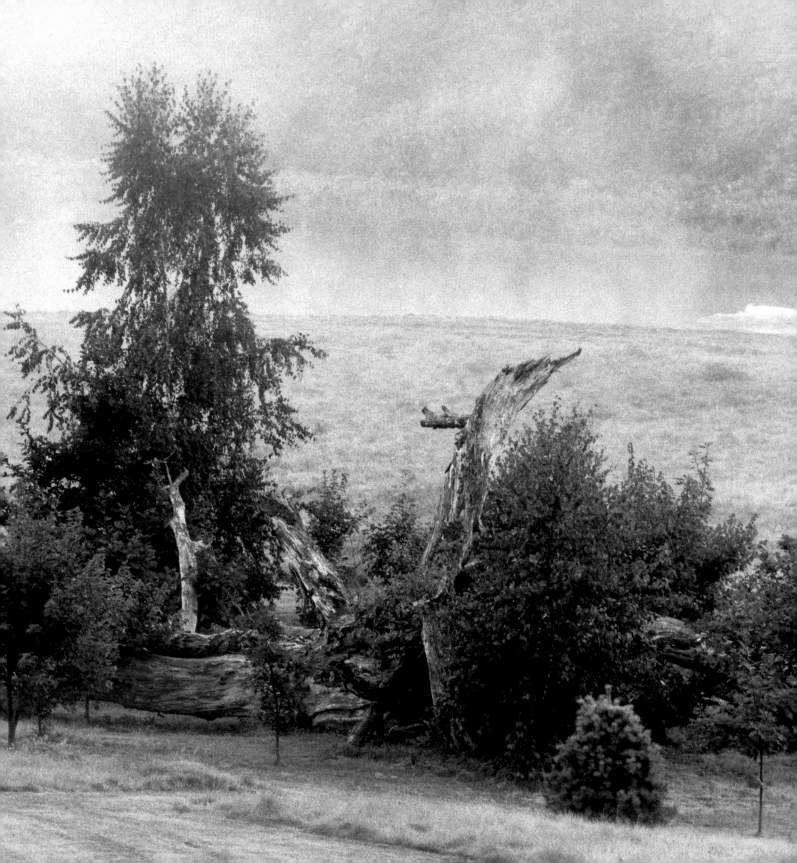

About Christmastime, I found a large, dead raccoon in a roomlike space under the oak. I wondered if it had been born in the tree and had come home to complete its own arc of life. It seemed safe under the tree, because all winter long no predator disturbed it.

We find the new forest more and more interesting all the time, and the old tree rotting in its midst remains a steady, dynamic presence. Big birds, even the Great Blue Heron, use its highest snags to survey the meadow.

Soon after we moved to Southborough, Judy and I developed the habit of taking visitors to the oak tree before they entered the house. It was the perfect way to reconnect with people, or get to know new acquaintances. When the tree came down, we stopped doing that, but now we're back to the same ritual. There's a path we call the "curly road," that goes down to the old oak and winds through the new forest.

Almost every time I leave the house, and then when I return, I walk out back and look out at the old tree and its new community of ongoing life. Often I think of our children trying to measure the oak. They would stand with their bellies up against the trunk, and their arms outstretched, trying to touch hands all around.

———

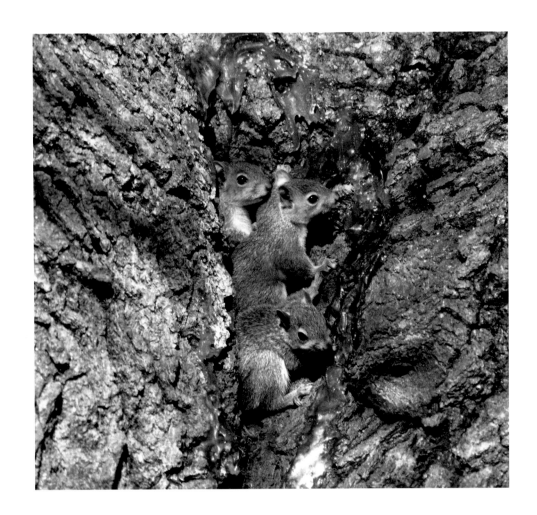

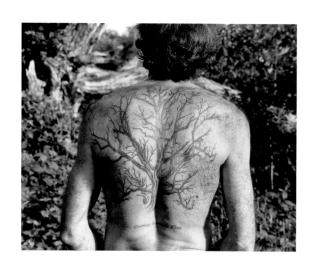

Acknowledgments

I am grateful to Susan Marsh for her graceful design of this book, her intriguing pairing and pacing of the photographs, and for her warm friendship. I'm grateful to Denise Bergman, whose editorial touch is as gentle and comforting as her lovely voice and laugh. I thank Thomas Palmer for his friendliness and good humor and for his insightful scanning of my photographs. I thank Danny Frank, visionary printer and steady coordinator of technology and artfulness. And I am grateful to the pressmen and foremen on the floor at Meridian. I treasure working with them. Finally, I thank Jim Mairs of Quantuck Lane Press, a storied publisher of wonderful books. I know I couldn't be with anybody better.

Also by B. A. King

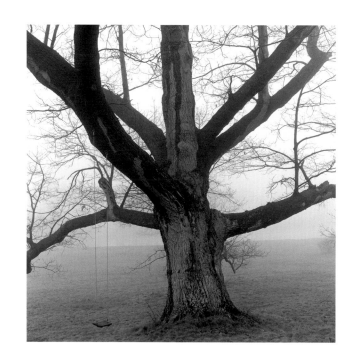

A BLACK ICE BOOK

DESIGNED BY SUSAN MARSH

TRITONE SEPARATIONS BY THOMAS PALMER

EDITED BY DENISE BERGMAN

TEXT COMPOSED IN "MRS. EAVES"

PRINTED ON PHOENIX MOTION XANTUR

PRINTED BY MERIDIAN PRINTING, EAST GREENWICH, RHODE ISLAND